MONTANA MAVERICKS

SHIPMENT 1

Paging Dr. Right by Stella Bagwell
Her Best Man by Crystal Green
I Do! I Do! by Pamela Toth
A Family for the Holidays by Victoria Pade
A Cowboy Under Her Tree by Allison Leigh
Stranded with the Groom by Christine Rimmer

SHIPMENT 2

All He Ever Wanted by Allison Leigh
Prescription: Love by Pamela Toth
Their Unexpected Family by Judy Duarte
Cabin Fever by Karen Rose Smith
Million-Dollar Makeover by Cheryl St.John
McFarlane's Perfect Bride by Christine Rimmer

SHIPMENT 3

Taming the Montana Millionaire by Teresa Southwick
From Doctor...to Daddy by Karen Rose Smith
When the Cowboy Said "I Do" by Crystal Green
Thunder Canyon Homecoming by Brenda Harlen
A Thunder Canyon Christmas by RaeAnne Thayne
Resisting Mr. Tall, Dark & Texan by Christine Rimmer
The Baby Wore a Badge by Marie Ferrarella

SHIPMENT 4

His Country Cinderella by Karen Rose Smith
The Hard-to-Get Cowboy by Crystal Green
A Maverick for Christmas by Leanne Banks
Her Montana Christmas Groom by Teresa Southwick
The Bounty Hunter by Cheryl St.John
The Guardian by Elizabeth Lane

SHIPMENT 5

Big Sky Rancher by Carolyn Davidson
The Tracker by Mary Burton
A Convenient Wife by Carolyn Davidson
Whitefeather's Woman by Deborah Hale
Moon Over Montana by Jackie Merritt
Marry Me...Again by Cheryl St.John

SHIPMENT 6

Big Sky Baby by Judy Duarte
The Rancher's Daughter by Jodi O'Donnell
Her Montana Millionaire by Crystal Green
Sweet Talk by Jackie Merritt
Big Sky Cowboy by Jennifer Mikels
Montana Lawman by Allison Leigh
Montana Mavericks Weddings
by Diana Palmer, Susan Mallery

SHIPMENT 7

You Belong to Me by Jennifer Greene
The Marriage Bargain by Victoria Pade
It Happened One Wedding Night by Karen Rose Smith
The Birth Mother by Pamela Toth
A Montana Mavericks Christmas
by Susan Mallery, Karen Rose Smith
Christmas in Whitehorn by Susan Mallery

SHIPMENT 8

In Love with Her Boss by Christie Ridgway
Marked for Marriage by Jackie Merritt
Rich, Rugged...Ruthless by Jennifer Mikels
The Magnificent Seven by Cheryl St.John
Outlaw Marriage by Laurie Paige
Nighthawk's Child by Linda Turner

MARRY ME...
AGAIN

CHERYL ST.JOHN

HARLEQUIN® MONTANA MAVERICKS

Special thanks and acknowledgment to Cheryl St.John
for her contribution to the Montana Mavericks series.

ISBN-13: 978-0-373-41832-9

Marry Me...Again

Copyright © 2003 by Cheryl Ludwigs

Recycling programs
for this product may
not exist in your area.

Printed in U.S.A.

Cheryl St.John's first book, *Rain Shadow*, was nominated for RWA's RITA® Award for Best First Book, by *RT Book Reviews* for Best Western Historical and by *Affaire de Coeur* readers for Best American Historical Romance. Since then her stories have continued to receive awards and high acclaim. In describing her stories of second chances and redemption, readers and reviewers use words like *emotional punch, hometown feel, core values, believable characters* and *real-life situations*. Visit Cheryl at her website, cherylstjohn.net.

Chapter One

Eight months ago

"He's still looking this way," Emma Carlisle said from behind her third rum and Coke. The animated woman was married and had three teenage children, but hearing her talk about the tall sandy-haired cowboy at the bar, anyone would think she was a teen herself. In fact, they'd have thought the entire group of nurses were high-school sophomores at the mall.

Rae Ann Benton elbowed Brynna. "He's heading this way. Act like you didn't see him coming."

"I *didn't* see him coming," Brynna replied, but her heart had leapt into her throat at the news that the six-foot-something hunk in the slim-fitting jeans, worn cowboy boots and faded chambray shirt was walking toward them. He'd been the subject of their lively discussion and avid appreciation for the past half hour.

When he strolled up to their table and gave a disarming grin, Brynna already knew that his name was Devlin Holmes, that he was better known as Devil and that he worked as foreman at his cousin's ranch outside town. What she didn't know—and couldn't have predicted— was that his flirtatious green eyes would take her breath away when he acknowledged the gathering of women with a polite hello and then singled her out with a confident nod.

"Care to dance?" he asked, his voice a stirring deep baritone that reached her toes.

The jukebox had started a lively Dixie Chicks' number that did make a person want to get up and move. Brynna never usually drank. Tonight she'd had two drinks and would probably trip and embarrass herself, but what the heck. She couldn't recall the last time she'd danced. She *wanted* to dance with

him. Her heart-pounding reaction to the guy was crazy.

Rae Ann's elbow dug into her side so sharply, Brynna practically leaped up out of her seat. If she fell and broke something, she was with the best nurses in the state of Montana, she thought giddily, catching her balance. The handsome fellow gestured toward the dance floor and she led the way across the wooden floor littered with peanut shells, conspicuously aware of his presence close behind her.

She'd showered at the hospital after her shift, changed into jeans and a sleeveless cotton top, and her shoulder-length hair had only begun to dry. She wasn't wearing a lick of makeup except lip gloss and a little blush she'd found on the top shelf of her locker. She couldn't imagine why the man of nurse dreams would look twice, let alone ask her to dance.

Dev thought the slender, fresh-faced beauty was the prettiest thing he'd seen in a long time, and she moved with a beguilingly natural sensuality that appealed to him on a purely masculine level. The single young women who normally came into Joe's Bar were made up for

a manhunt—makeup, perfume, tiny T-shirts that bared their midriffs, low-slung jeans that usually revealed tattoos. There were also the older manhunters with more skin covered, but with smiles every bit as predatory.

This young woman's smile was a little nervous, a lot embarrassed, and even if he hadn't been coming here and knew she wasn't a regular, he'd have known just by observing her discomfort. "Name's Devlin Holmes," he said, leading her to the small dance floor, where several couples parted to make some space. "Call me Dev."

"Brynna Shaw," she said over the blare of the music.

He took her soft yet sturdy hand and led her through the dance steps, and, after a few minutes, she loosened up and seemed to enjoy herself. Her golden-blond hair bounced on her shoulders under the dim lighting. Her expressive brown eyes did something strange to his insides. She smelled like soap and shampoo, mingled with the faintest hint of almond. The alluring smell enticed his senses. The sight and scent of her hair had him wanting to touch it. It had been a long time since a woman had attracted him the way this one did.

Somehow, as soon as he'd seen her, he'd known she was special. Maybe it was the fact that she seemed out of place here or that she was obviously embarrassed and yet pleased by the fact that he'd singled her out that made him want to know her.

Being this close made him want a lot more.

After a line dance and another fast number, a slow Garth Brooks song played. Tentatively, Dev took her hand and drew her close, pleased that she didn't resist. She rested her other hand on his shoulder and glanced up. Looking into her eyes, his heart increased its speed. He suddenly felt like the luckiest man in Montana. How could he have missed her until now? "You live in town?" he asked.

She nodded. "I have an apartment down the street."

"I haven't seen you here before."

"I usually go straight home after work."

"Where's work?"

"The hospital in Whitehorn. I'm also on staff at the clinic here in Rumor."

"Nurse?"

"Third-year resident."

His eyebrows rose. "No wonder you're tired after work. I've seen *ER,* it looks exhausting."

The warmth of her genuine laugh wound its way around his heart. He definitely liked making her laugh.

"It's not quite that exciting," she denied. "We're a small town, you know."

"Just the same, you see all the interesting cases."

"Well, some." She shrugged. "I'm an ob-gyn."

Dev laughed aloud. "I'm not going to comment."

"Thank you. I've heard them all."

Her body relaxed even more after their introductions, and within moments, she was leaning into him, her soft curves pressed against the planes of his chest and hips; she fitted there as if she was made for him. He couldn't believe his good fortune. What had he ever done to deserve this?

After another slow dance, he asked, "Would you like to get a fresh drink and talk for a while?"

To his delight, she agreed. Her friends smiled and waved with waggling eyebrows when he led her to a booth along the back, where the music wasn't so loud and the lighting was more intimate.

Ignoring them, Brynna tasted the drink the waitress sat on a napkin before her. She'd worked up a thirst. If someone had told her this morning that she'd be dancing with a handsome cowboy, let alone letting him buy her drinks, she'd have ordered them a psych exam. She was the most sensible, least impulsive person on the planet. She never did anything like this.

But it had been a harrowing day at the hospital. She'd lost a mother with leukemia she'd been trying desperately to save. In order to protect her unborn child, the young woman had refused the chemotherapy she needed, so there had been little Brynna could do, except turn her over to the oncology team once the baby was safely delivered.

Even now, thinking about Heidi Price, regret washed over her. The sound of pool balls clacking together and muted cheers came from a side room, and she couldn't help thinking how odd it always seemed that lives went on unaffected when others were experiencing tragedies.

As though sensing the shift in her mood, Dev asked softly, "Something wrong?"

She drew a circle in the condensation her

glass had left on the table and spoke the difficult words. "I lost a patient today."

"That must be tough."

Brynna agreed. "She was twenty-four. Had leukemia, but refused treatment because of her baby."

"I guess there wasn't much you could do."

"It was frustrating."

"What about the baby?"

Gauging his sincerity, she gazed into his eyes. His earnest tone and concerned expression showed he really cared. "She's four weeks early, but doing just fine."

"That's good."

His compassion touched her, and Brynna nodded. "I had to tell her husband that his wife didn't make it."

He studied her for a moment. "How do you do that?"

"Well...I've never had to do it before. I was taught to explain the facts. Answer the questions. But then you see the pain...the grief... and...." Brynna's throat tightened with the words and the remembrance. She had felt like crying all afternoon, but she hadn't allowed herself to let go. She was a professional.

"And what?" Dev asked, urging her to go on.

This man not only had her examining her inner feelings, but sharing them. She found herself saying things she didn't share with anyone else. "I don't know how to detach and be merely the doctor and not a caring person," she admitted.

"You *are* a caring person, or you probably wouldn't be a doctor. The two aren't separate, are they?"

With a lump in her throat, she shook her head.

His hand covered hers then, warm tactile comfort that sent an enticing shiver up her arm. Without conscious thought, Brynna turned over her hand and laced her fingers through his, their palms touching. His tanned hand was large, with long fingers and calluses she felt against her palm—so different from her own—so entirely masculine. It was an intimate touch. A sexy, familiar touch that set off a battery of butterflies in her chest and made her wonder how his hand would feel on other parts of her body.

She should have been ashamed of her thoughts, but the sensual contact released a deeply buried longing—a longing for something more than years of school and work and

self-denial. His touch brought her single status sharply into focus.

Face warming uncomfortably, she glanced up to notice his thick blond hair with a ridge where his hat had been and his crescent-shaped eyebrows. Both hair and brows were bleached from the sun. He was strikingly handsome, but there was something even more attractive about him than those intriguing eyes and sexy mouth. The way he looked at her made her think of wet lingering kisses and the slide of bare skin.

The words to a song about slow hands registered in the background. A burning warmth that had begun in her chest flowed through her abdomen and pooled at the center of her femininity. This man's touch melted her insides. The way he gazed at her had her hot enough to combust. She swallowed and met his sparkling green gaze. Could he tell the effect he had on her?

He smiled, one side of his full lips drawn up in a secret grin that created a sexy dimple in his cheek. Surprising herself, she studied his mouth and wondered what it would feel like to kiss him. Would he be an aggressive kisser? Would his lips taste like the beer in the glass on the table? Would his tongue?

If she didn't know it was physically impossible, Brynna would have sworn her heart turned completely over in her chest at the thought. The temperature in the room seemed to double. She found it difficult to breathe and inhaled quickly through parted lips.

Dev obviously noted her sharp intake of breath, the parting of her lips, the rise of her chest, and his gaze, glittering with masculine interest, dropped to her breasts before he dragged it back to her mouth. The smile had disappeared from his lips, and his perusal was now surprisingly serious. Had he been imagining kissing her, too?

She didn't want to let go of his hand, and he didn't seem inclined to break the contact either. She felt like clinging to him, and it was a good thing the table was between them or she'd have embarrassed herself by pressing against his body and melding into him. Remembering the solid strength of his arms and chest as they'd danced that last dance made her head a little dizzy.

The waitress set down a full glass and a fresh pitcher of beer. Reluctantly, they broke the contact of their entwined fingers, and Dev

placed money on the tray. The girl thanked him and picked up Brynna's empty glass.

Brynna glanced at the gimlet, a lime twist perched on the rim. No wonder she was feeling light-headed. She'd had too many drinks. Obviously the liquor had gone straight to her head for her to be having the dangerous and uncharacteristically erotic thoughts she'd been having about the man sitting across from her.

"I think I've had enough," she said.

When she looked up again, Dev's brows were drawn together in a question—or was that disappointment?

"Drinks," she clarified.

His expression smoothed into a lazy smile. "We could order coffee," he suggested. When she didn't readily agree, he added, "Or go outside for air."

As if only just noticing where they were, she glanced around. They'd been sitting here holding hands and staring at each other like googly-eyed teenagers, but thank goodness, the back of the booth where Dev sat prevented almost everyone in Joe's Bar from seeing them. Brynna didn't want to part company just yet, and fresh air would probably do her good.

"Okay." She stood and led the way through the dimly lit room to the table where her friends were sharing a basket of buffalo wings. Rae Ann was missing, and Brynna spotted her on the dance floor. "We're going for a walk," she said to Emma and the other two nurses.

Emma reached under the table, brought up Brynna's backpack and gave the couple an innocent smile, but Brynna knew as soon as the door closed behind them, tongues would wag. "See you later," Emma said.

As soon as Dev touched the small of her back, guiding her toward the exit in a decidedly possessive male way, a shiver ran up her spine. He grabbed a black Stetson from a row of similar hats on hooks, slowed to allow Joe, the resident rottweiler who guarded the door, to sniff them as they passed, then held open the door.

The air was damp, but cool, the refreshing summer scent bringing with it a sense of starting over. The dark shiny pavement indicated it had rained while they'd been inside Joe's.

Dev took her bag and slung it over his shoulder. "Which way?"

She didn't want him to think she was invit-

ing him to her place, which was straight ahead down State Street—and which *was* what she would really have liked to have done—so she pointed left on Main. "That way."

"You live alone?" he asked after they'd walked a few paces.

She nodded.

"Have family in Rumor?"

"My younger sister Melanie and her family live west on Logan. She's married and has two boys. My brother Kurt just turned twenty-four, and he's the pharmacy tech at Value Drug Store. My little brother Tuck is nineteen and stays with each of us off and on. He'll be going to college in the fall."

Right next to Joe's was the Rumor Motel, and as they passed, Brynna thought maybe it would have been better to go the other way. Dev might think she was hoping for an invitation.

If he thought anything, Dev didn't reveal it or react; he simply walked on past the Rooftop Café and led her across the street where they turned and strolled toward the library.

"What about you?" she asked. "Family?"

"My cousin runs a spread about fourteen miles that way." He pointed ahead in a south-

easterly direction. "You probably know the Holmes Ranch."

She nodded. "Colby is your cousin?"

"Yep."

He wasn't volunteering information, so she asked, "Where are you from?"

"Raised in Seattle."

"Your parents live there?"

"Yep."

"Montana is quite a change from Seattle."

"Ever been there?"

"No. I'm just imagining."

They passed the courthouse, the lawn lit by old-fashioned converted gas lamps, just as a gentle rain began to fall, a cool sprinkling against Brynna's warm skin. Dev led her toward the shelter of the shadowy white gazebo. He climbed the stairs and dropped her bag on a bench, and she followed, standing and gazing out at the rain falling on the street.

When she turned back, he was only inches away, having removed his hat. He studied her, his green eyes black in the dark. The dampness brought the clean scent of his shirt and skin to her nostrils. That heavy feeling in her abdomen returned full-force, and she had an overpowering urge to touch him. What would

he think of her if he knew—if, heaven forbid, she had the boldness to actually act on her desires?

She didn't have to find out, because he raised his hand first, his fingers brushing hair away from her cheek and lingering to caress the strands between his thumb and forefinger. They stood so close, she could feel the warmth radiating from his body. It was crazy, but she could feel herself being drawn toward him like a magnet.

"I want to kiss you, Brynna."

Her heart skipped a beat. *Finally.* She'd never done anything this impulsive, but she'd never wanted anything more than she wanted to experience his kisses at this moment.

"Yes," she said without hiding the impatience in her breathy voice.

She met him in an eager embrace, and the question of his kisses was answered to her delirious pleasure. His mouth tasted like beer, warm and yeasty; his lips were firm and he applied just the right amount of pressure. He allowed her to breathe and enjoy and even pull away, if she had wanted.

She didn't.

No, no, no, she didn't....

Senses reeling, she melted against him, placing a hand flat against his shirtfront and angling her head for closer, deeper contact. Immediately he folded her against his body, splayed the fingers of one hand over her spine and the other behind her neck, in her hair, his thumb along her jaw. Like the parched ground eager for sustaining rain, she couldn't get enough of him.

She drank him in, absorbing warmth, comfort, passion, without any inhibition.

Brynna was a sensible woman, a woman with responsibilities who planned meticulously and took care of other people. Doing something just because she wanted to was out of her limited experience. It felt strange. It felt scary.

It felt wonderful.

If there was such a thing as a biological clock, hers hadn't merely been buzzing—it had been gonging like Big Ben, but for the past several years she'd been hitting the snooze button. Though she loved her job, she wanted a relationship. A family.

Not a one-night stand with a man she'd just met.

Their lips parted, giving them time to breathe, and, in those heart-pounding seconds,

Brynna tried to collect her thoughts. Dev still stroked her cheek with his thumb. The touch went all the way to her breasts and hardened her nipples. Greedy for the feelings he created so easily, she closed her eyes on the erotic sensation and dropped her head back. It seemed as though she'd been waiting for his touch forever.

Dev took the opportunity to dart his tongue against the sensitive skin of her neck, press a dewy kiss under her jaw…beneath her ear. "You taste so damned good," he whispered, and she shuddered with the pleasure of his damp breath in her ear. He slid his other hand from her back around to cup her breast. Even through the fabric of her shirt and bra, his caress was hot and her nipple stiffened. He found it with the tips of his fingers.

Brynna sighed, almost a hiccup, almost a sob, but definitely a sound of sensual delight. Her knees had turned to jelly, and she didn't know how much longer she would be able to stand like this, without melting into a puddle.

This man made her lose all reason, and she was tired of denying herself, tired of thinking about nothing but school and work and sensible things. It was time to take a chance.

She deserved a sexy cowboy with slow hands and mesmerizing kisses. She deserved Devlin Holmes…and the pleasure he promised.

Chapter Two

She buried her face in his neck and inhaled the intoxicating scent of his skin, then instinctively tasted him. "If we cross the street and run through those backyards, we'll come out right at the back of my apartment building," she said softly, brazenly, her heart leaping at her daring as well as the thought.

He leaned back enough to see her face in the dim glow of the distant street lamps. He stood with her pressed against the entire length of his body and her blood thrummed in her veins. "Are you sure?" he asked.

"It's my birthday," she replied, as if that ex-

plained her decision to throw caution to the wind with a stranger, and then she felt silly for mentioning it.

"You didn't say anything." He sounded more surprised at the fact that it was her birthday than because she wanted to take him home to her bed. He probably got a lot of offers.

She shrugged and wondered if perhaps he wasn't all that interested. Maybe hard-up doctors weren't that much of an oddity. Disappointment flashed through her veins.

He stroked her bare arms. "Give me five minutes to run back across Main Street to the gas station, okay?"

Her relief was so potent, it should have been embarrassing.

He released her shoulders and stepped away. "If you're not here when I get back, I'll know I dreamed you."

"I'll be here." Unless the world ended or she woke up. God, she hoped she *wasn't* dreaming.

He grabbed his Stetson and dashed out into the rain, his boots squishing on the sodden grass.

She had a watch. It only took him four minutes, and he was back, barely breathing hard,

his hat dripping, his shirt plastered to his broad chest. "You're here," he said.

"Waiting," she replied with a nod.

Slowly he removed his hat and settled it on her head. Then picking up her backpack, he took her hand, and together they ran across the street. They cut a path between the homes, across backyards and toward her apartment complex. Her knees were still weak with passion and excitement, and she struggled to keep up with his longer, more confident strides.

Beneath the overhang that protected a small back stoop, Brynna unlocked the entry, then led him up a flight of orange-carpeted stairs to her door. Her fingers trembled so hard she dropped the keys. With a gentle hand on her shoulder, Dev pressed her against the wall, eased his rock-solid body against hers and kissed her, knocking his hat from her head to the floor. She wrapped one arm around his neck and met the invasive mind-reeling quest of his tongue. Her imagination couldn't have come up with anything better than Dev's kisses.

Again, she forgot where she was until he loosened his hold and separated them to quickly scoop up her keys and his hat and unlock the

door. Brynna groped for the light switch that turned on a lamp at the end of her sofa.

Dev let her bag fall and glanced around. He met her gaze.

Lips tingling, body thrumming, she smiled hesitantly and kicked off her shoes.

"Maybe we should get out of these wet clothes," he suggested. standing his hat on its crown on the floor.

She locked the door behind her and walked toward the hall. "I'll grab towels while you get those boots off."

She stepped behind the half-closed bathroom door and unbuttoned her shirt, dropping it and her bra into the tub. Her socks and jeans came next. Slipping into her terry robe, she carried a towel back to Dev.

He had removed his wet shirt and draped it over the back of a chair. Her mouth went dry at the sight of all that smooth golden skin, his loosened belt and gaping jeans. He was tanned and firm, with enticing shadows in the muscled contours of his arms and chest, and she imagined touching her tongue to those places....

Trying to stay rational, Brynna reached up with the towel to dry his hair. He allowed

the act for only a moment, before pulling her close and kissing her. She touched his chest and shoulders with seeking fingers, as if she were blind and could read every inch of him. Her exploration took in his throat, then his cheeks, where the textures contrasted.

He pulled away and scraped his jaw with the backs of his fingers. "I haven't shaved since this morning. Didn't know I was going to... do this...."

"It's okay. I kind of like it." He smiled and she placed her finger on the dimple his grin created. "I like that, too."

"I could shave if you have a razor."

"No."

He cocked a brow.

"I mean, I have a razor," she explained, "but I don't want you to shave now."

"But I want to kiss you."

"I want you to kiss me. I just don't want to wait." She blushed at her impetuousness—her impatience.

Obliging, Dev ran a finger down the front of her pale-yellow robe and spread the fabric to the side until one breast was exposed. Her nipple puckered shamelessly, but she didn't mind him looking at her. He lowered his face

to the swell of her breast and pressed a kiss there. "Not too rough?"

"No-o." Had she managed to say that out loud? "No," she reiterated, in case the word had only been in her head. Brynna made a conscious effort to think clearly and realized then that Dev had barely made it inside her front door before she'd succumbed to the sublime pleasures he offered. Hating to interrupt the attention he was giving her breast, but needing to move them to a more comfortable location, she took his hand and led him down the hallway to her bedroom.

She stood just inside for a moment, seeing the room with his eyes. It was by no means a lover's den. Her bedroom was functional and represented her busy life, with a desk and filing cabinet in one corner, a treadmill in the other. The light from the hallway was enough to illuminate her plain double bed with unimaginative plaid sheets and the comforter she hadn't even bothered to pull up that morning. No one ever saw her bed.

Devlin obviously couldn't have cared less whether her bed was made. He released her hand, wrapped his strong arms around her and kissed her so thoroughly, she forgot to be em-

barrassed by the intense situation and her lack of finesse. He stroked her throat, touched her hair, and the fire was back.

Minutes later, he was backing her toward her bed, edging the robe from her shoulders, and she gladly helped him in the task of peeling damp jeans down his hips and off into a heap on the floor. They fell back on her bed, their bodies touching flesh-to-flesh—his legs cool because of the rain-soaked denim he'd just removed.

Dev stretched out over her, his weight a delicious mix of pleasure and torment. Holding him, touching him, was so much more emotionally and physically gratifying than anything she'd ever experienced...wanting him wasn't enough...not nearly enough...yet wanting him was everything.

Somehow, Brynna knew that this experience with this man was going to be something extraordinary. It was already enough to bring tears to her eyes.

She kissed his neck...cupped his jaw and tasted his incredible thrill-inspiring mouth by gently sucking his lower lip, then seeking his tongue and deepening the contact, needing to become a part of him.

This was crazy—crazy wonderful.

Dev kissed her in return, his hand sliding across her shoulder to her breast. His mouth left hers to taste the nub he'd worked to a rigid point, and Brynna closed her eyes against the intensity of the sensations. She'd been ready and willing since sitting across from him at Joe's—and she appreciated his efforts to prolong the inevitable—but she really didn't think she could wait any longer.

When at last he slid his hand down her hip, across her belly and between her thighs, intuitively knowing just how and where to stroke, she bit her lower lip and held back a cry. He kissed her, as though he understood her frustration and shared her impatience. Without verbal communication, he knew to move away, grab the foil packages from his jeans on the floor and return for her assistance.

Within seconds he was sheathed and pressing into her willing flesh. Stars burst behind Brynna's eyelids as waves of pleasure washed over her, coursed through her and stole all breath and reason. He was incredible. This moment was perfect. She had only ever imagined anything this good.

Devlin slowed his movements, kissed her

tenderly...told her in a few clipped words how hot she made him...and in moments she discovered her imagination was a void where this man was concerned. He cupped her hips and angled her body so he could penetrate her swollen readiness more deeply, then gently, determinedly, eased her into another shattering climax, after which he found his own release and fell to her side.

Dazed and lethargically replete, Brynna turned on her side to gaze at him. She laid her palm against his chest, where his heart slowed to an even rhythm beneath her touch, and studied his face in profile. He had closed his eyes. One hand lay limp on his belly. His skin glowed from exertion. What a mind-numbing experience that had been, Brynna thought, thinking how uncharacteristic it was of her to do something so—impulsive.

Oddly, she didn't care. Maybe she would later. Maybe tomorrow she'd be consumed with regret and shame. But not at this moment. Not feeling the way she did and not while looking at Devlin. A smile touched her lips.

Could the experience possibly have been as incredible for him as it had been for her? Had it meant anything to him, or was she just an-

other in a long line of one-night flings? The thought was like a shard of glass to her chest. She was nothing if not realistic and practical. Devlin Holmes would probably sleep for a few hours and then slip out of her apartment to disappear, except for an awkward moment every once in a while, where she ran into him at MonMart or the gas station. How would she feel?

He rolled his head toward her then and opened his eyes to look at her with an expression she would have called awe if she weren't down-to-earth and reasonable. He rolled toward her, raising the hand from his belly to her cheek. "Hey."

She gave him a half-embarrassed smile, wondering how she could assure him she didn't expect him to stay for breakfast, or even to use the rest of those condoms.

He looked into her eyes and said the last thing she would ever have expected. "Will you marry me, Brynna?"

Chapter Three

The Present

Brynna arranged two china plates, silverware and napkins in silver rings, then placed a pair of candlesticks holding ivory tapers in the center of the dining room table and paused. Too obvious, much too obvious. This looked as though she was setting the scene for a seduction. Plucking the candlesticks from the table, she stood holding them… considering…rethinking …changing her mind yet again.

She *was* setting the scene for *something,* after all—dinner! She and Dev shared a can-

dlelight dinner a couple of times a month, whenever their schedules allowed, so why shouldn't she set a romantic table?

Replacing the candles, she laid a book of matches nearby and studied the setting again, turning the bouquet of freshly cut daisies for the best effect. Dev liked daisies. She hoped he had remembered their arrangement and would be here on time.

She glanced at her watch, deliberately shoving concern away. More than once, he'd forgotten their planned evening and had been off flying somewhere while she waited. His forgetfulness had been a point of contention on more than one occasion.

Marriage was still new to him, Brynna thought, justifying his underlying wanderlust as she always did. Eight months was barely enough time to get to know each other, lct alone change a lifetime of habits. Before marrying her, he'd never had to be accountable to anyone, never had to take another person's feelings or schedule into consideration, so considering all that, he was doing great. And only occasionally did she allow his wild ways to strain her patience.

She just didn't know how he was going to

take the news she was going to lay on him tonight. Every day, every situation with Dev was like sailing uncharted waters. Anxiety tied her stomach in a knot.

Headlights swept across the picture window in the living room, indicating Dev's pickup had turned into the driveway. Relief washed over her at the same time as anxiety pricked at her nerves. Brynna placed a hand over her chest and took a deep breath to calm herself.

Quickly, she lit the candles and turned off the overhead light.

The front door opened, and her tall handsome husband entered the living room, tossing his hat on a nearby bench and immediately looking for her. A warm rush of affection flooded over her as it always did when she saw him—when he made her feel so special. "Hey, sweet thing," he greeted her.

She headed toward him with a smile. "You're on time."

He met her in the doorway to the dining room and, taking her elbows in his warm hands, gazed down at her with tenderness. "This is our only evening together this week. I wouldn't miss it."

"Remember Friday evening is Tuck's birthday party at Melanie's place," she said, touching a finger to his chin. "Don't miss that, either. I'll be on call, but I should get to spend part of the evening there."

He wrapped his arms around her and hugged her soundly. "I'll be there."

When he loosened the embrace and lowered his mouth to hers, Brynna met his lips and kissed him, amazed that she still felt such excitement every time she saw him. In eight months, the blush of first love had not waned. She never ceased being grateful that she'd found him, but a wariness always accompanied her joy. How long would a free spirit like Dev be happy with her and with this life?

"You cooked," he said, releasing her and glancing over her shoulder with appreciation.

"I did."

"I'll pour the wine."

She moved toward the kitchen to get the food. "None for me, thanks."

He glanced at her. "Well, then, I'll decline, too. No sense opening a bottle just for me. Can I help?" He moved into the kitchen and washed his hands at the sink.

"When have I ever turned down help?"

He grinned and kissed the back of her neck before moving on to his task. Dev was a toucher, spontaneously caressing her or laying a hand on the small of her back in passing. He had a natural way of making her feel loved and important. Some days she'd felt so lucky, she'd wondered when it would all come crashing down. And she prayed this wasn't the day.

Once the food was on the table, they sat. She passed the dishes and they ate.

"Someone offered to buy *Sky Spirit* today," he said, slathering butter and sour cream on his potato.

"Again?" He was referring to his pride and joy, the ultralight plane he'd built.

"A guy I met in Denver."

"You were in Denver today?"

"This morning." He tasted the steak she'd grilled to perfection. "Mmm, this is delicious."

Brynna could barely keep track of his activities. Some days he worked at the Holmes Ranch, but others he spent flying. She hadn't known much at all about Dev when she'd married him, nothing save the fact that he

set her on fire and she couldn't take another breath without him in her life, but she'd quickly learned that he didn't work at his cousin's ranch for the money.

Dev was the second son of a well-to-do family, college-educated. He assisted with the family business when duty forced him to do so, and, having tried his hand at ranching and finding he enjoyed it, Dev now preferred to work for his cousin for a mere pittance.

His main activity was flying the ultralights he built and sold for a nice profit. The only one he hadn't sold was his favorite, *Sky Spirit*. He also owned and flew a Cessna 206 as well as a Piper Seneca that he kept in hangars at Lee Henderson's airfield north of Rumor. His inability to stay in one place very long kept him on the go.

"It was awesome flying weather today," he told her. "You would have loved the sky over Colorado."

She smiled indulgently. "I'll bet I would have."

His aviation ability had come in handy the night he'd flown them to Las Vegas to get married. Brynna had refused to go that first night—the night after they'd made love for the

first time and he'd proposed. They'd both had too much to drink. She hadn't wanted to make decisions, and she hadn't wanted him piloting a plane until they were both stone-cold sober.

Three days later, just as crazy for him and without a single drink, she'd agreed to fly to Nevada and be married. Since then he'd made several international trips and numerous flights in the States, but her job always prevented her from joining him. The next flight he had planned for them was a honeymoon on an African safari in the fall. Brynna had already planned for the time off between internships. "I wonder what the sky looks like over Nairobi," she said teasingly.

Dev laid down his fork and took a drink of his water. "I don't know, but we'll find out."

Her thoughts reverted immediately to what she had learned that day and how it would affect their trip. They finished their meal, and Dev carried the dishes to the kitchen. He opened the dishwasher, but she stopped him with a touch on his arm. "Leave them."

He took her hand with a grin. "You have plans that can't wait?"

She nodded, turned and took a glass bowl from the refrigerator.

Dev cocked a brow at the chocolate confection she held. His green eyes flashed intrigue and desire, and a slow grin carved a sexy dimple in his lean cheek. "For here or in the bedroom?"

Brynna blushed. The man was infinitely creative and ever so willing to please. "At the table, Dev."

He shrugged. "Okay."

She spooned a dollop of mousse into each of their dishes and they sat.

Dev leaned forward and touched her forehead with one finger, as if to smooth out a worry line. "Something wrong, sweet thing?"

Brynna folded her hands in her lap, then thought better of looking too nervous and brought them up to twist her napkin. "I have something to tell you."

"Okay." He laid down his spoon and waited, an inquisitive smile on his lips.

Her heart thudded erratically, and she swallowed. Fear of not knowing his reaction paralyzed her.

"Brynn, what is it? Is something wrong?" Immediately sensing her distress, he got up

from his seat and moved to crouch on one knee at her side. He cradled her cold hand with his strong warm fingers.

Gathering courage from the love and concern in his green eyes, she took a breath. "Dev, I'm pregnant."

Chapter Four

The words didn't register on his face for a moment, but she knew the instant they clicked in his brain. A wrinkle formed between his brows. "Are you sure?"

She nodded. "I'm an ob-gyn," she said needlessly. "I saw the ultrasound myself."

"Yes, of course, but…but how? We're careful every time."

More than a little disappointed that he was questioning the technical aspect while she was suffering the emotional impact, she concentrated on his question. "You know I'm not a supporter of many forms of birth control, be-

cause of potential side effects. I know there are risks with every method, but we were being doubly safe with…" She didn't really need to explain to him—he was there every time she used a contraceptive foam and he a condom.

"Well, these things happen," she went on, "even though every precaution is taken. I see this in patients now and then."

He looked at her with disbelief edging his expression and then sat squarely on the floor as though he might fall over if he didn't ground himself. His face plainly registered the shock he was feeling. "You're *pregnant,* Brynna?"

She nodded and blinked back tears of disappointment at his reaction. He needed a little time. She'd had a couple of weeks of suspicions to get prepared. Besides, she wanted a family more than anything.

He jammed the fingers of one hand into his fair hair and gazed unseeingly into space. His silence unnerved her.

Brynna got out of her chair and lowered herself to the floor beside him. "I didn't do this on purpose, Dev."

He met her eyes immediately. "I never thought you did."

"I just didn't want you to have a doubt."

"I don't. Why would I doubt you?"

She shook her head. "I don't know. Because it's never been a secret that I enjoy helping people create families and that I've always wanted my own family. I want one for us."

"I never said I didn't want a family," he said defensively.

"You just aren't ready. Not right now."

"I don't know. Don't put words in my mouth. Don't think for me."

"Then tell me what you're thinking. Please."

He gestured with an open palm. "I'm dumbfounded. I hadn't thought about this. I hadn't planned on…"

"A baby," she clarified.

"No. I hadn't planned on a *baby*. *We* hadn't planned on it."

"You're right. We hadn't. But it's happened, and now we just have to count our blessings."

He nodded without conviction. But he didn't meet her eyes for a long moment.

"It's not the worst thing that could happen, Dev. We'll have a family sooner than we planned, that's all."

"You're just a year away from setting up your practice," he pointed out.

Brynna took his hand. "I can keep working up until the last few weeks. After the baby comes, we can hire someone to help. I can have my career and be a good mother, too, Dev, I know I can."

"I believe you can, too," he said. He stood, still holding her hand, and helped her to her feet. As an afterthought he asked, still looking at the floor, "How pregnant are you?"

"Eight weeks," she replied.

"How many weeks does it take?"

"Forty."

"Is that all?" He rubbed a hand down his face.

He didn't ask her how she felt, if she had morning sickness or what she was feeling. Tears threatened and Brynna blinked them back.

"That means he would be born when?"

"He...or she," she replied, quoting the due date she had calculated.

He nodded, as though figuring the event into his schedule or planning how much he could fit in before he was tied down.

Brynna turned to the table. "Do you want your dessert?"

"No," he replied distractedly. "Thanks."

She carried the dishes into the kitchen and returned to blow out the candles.

Dev was standing in the doorway to the living room, leaning against the jamb. The light from the hall silhouetted his tall frame. Overshadowing her love for him had always been the fear that any children of theirs would be neglected while he pursued his carefree flying. Dev wasn't used to being tied down.

Devlin Holmes was the only impulsive thing she'd ever done in her life and she prayed she wasn't going to regret it. Thinking she might terrified her. She loved him so much it hurt.

She walked to him, and he enfolded her in a strong embrace. Brynna laid her cheek against his solid chest and allowed a tear to dampen his shirt-front.

"I love you, Brynna," he said softly, his voice the stirring baritone she loved.

"I love you, Dev," she replied hoarsely.

He rubbed her back and cupped her buttocks, his touch arousing feelings of passion and need as it always did. He kissed her and she melted against him.

"Is it okay to make love?" he asked.

"Yes, of course. We make love all the time, don't we?" She took his hand and led him to the bedroom.

The following morning, Brynna stood before the mirror in her chemise and panties and studied her body, her barely swelling abdomen negligible proof of the life within her. She touched the place where their child nestled and tried not to think of Dev's reaction the night before. His focus on flying reminded her frighteningly of her parents' obsession with their own private lives.

Norman and Audrey Shaw had been loving toward each other, but never attentive to their children. Brynna had often wondered why the couple had bothered to create and keep four children. She'd thought they would have discovered after the first one—her—that they weren't cut out to be parents.

Her father worked his eight-to-five job at the lumber mill and her mother as a file clerk at the courthouse. Once the two hit the door after work, they were right back out pursuing their own interests, keeping Beauties and the Beat as well as Joe's Bar in business, traveling

to flea markets and trade shows on the weekends. Her father bought and sold rare coins.

Once Tuck had graduated, they'd bought an RV and hit the road. Brynna had always been the emotional stability for her siblings. She'd prepared their meals, washed their clothes and helped them with schoolwork.

She didn't want to be the solitary backbone of her own family as she had been for her birth family. She didn't want a family without Dev's help. She couldn't bear to be alone in this marriage.

Dev had more money to play with, but he was preoccupied with his own interests, just as her parents had been. She didn't believe for a moment that he'd ever be unfaithful. She just didn't think he knew how to commit. His reaction to her pregnancy confirmed that.

Brynna had worked hard to get this far in her career. Focus and responsibility had brought her to this point. She'd done this on her own and she wasn't going to give it up. But she wanted this baby, too. A family. She had a horrible feeling that she'd made a mistake in impulsively marrying a man she didn't know well. It was a feeling she couldn't shake.

The next two evenings Brynna worked, and

when she came home, Dev had been waiting for her with a light meal. They made small talk, though neither of them mentioned her pregnancy, and the subject hung between them like an invisible wall. Brynna's defenses were more on alert than ever. Would Dev come around…or had this pushed him away?

Would she come home some night to find him gone? His things missing? Preparing herself for that possibility, she distanced herself a little more each day.

Friday evening after work, Brynna showered and dressed for her younger brother's party, concerned because she hadn't heard from Dev since that morning, and he hadn't been here to greet her after her shift. She fixed her pager to the snug waistband of her slacks and tried calling Dev's cell phone. She got his voice mail and left him a brief message, asking where he was.

Glancing out at the hazy sky, she grabbed a light jacket and drove to Melanie and Frank's comfortable ranch-style home. The acrid scent of smoke hung in the air, and Brynna scanned the horizon, spotting a dark cloud in the direction of Logan's Hill. They hadn't had rain

for weeks on end, and the reports of sporadic fires were frightening. This one looked close.

Her brother-in-law met her at his door.

"Where's the hunk?" Frank asked, glancing behind her. He'd teasingly referred to Dev as the hunk ever since hearing how the nurses at the clinic considered him eye candy.

"I don't know. I couldn't get him on the phone. Where's the birthday guy?"

She had seen Tuck's car in the drive.

"Out back. Your sister is grilling, though I warn you, I am the master chef. So far, so good, though."

"Frank, did you see the sky to the northeast? There's a fire."

"I'll flip on my police scanner and listen. Go on out back."

Brynna made her way through the house and out the sliding doors from the dining room to a roomy deck where Tuck sat at a picnic table with his nephews, playing with plastic action figures.

John, six, and Chandler, four, jumped down from their seats to run and greet their aunt. Brynna gave them hugs and kissed their cheeks. "It's Unca Tuck's boofday," Chandler told her, his blue eyes wide with excitement.

"I know," Brynna replied. "Are we going to have cake after supper?"

"Uh-huh. And we gots a supwise for him, too, but I'm not apposed to say it's stuff for him to take at college."

"Well, don't say it then," Brynna replied with a grin.

"It's not toys," John added without enthusiasm.

"That's probably a good thing," Brynna replied, "because Tuck won't have time to play with toys at college. At least I never did."

"I'm taking my Game Boy," Tuck interjected. "I have to have something to do besides study."

"Can we play with your Game Boy now, Uncle Tuck?" John asked.

"After supper," Melanie replied from her position at the grill.

John and Chandler jumped up and down in delighted anticipation. The steaks smelled incredible, and Brynna's stomach growled.

"Have you received all of your grant forms and finished all the paperwork?" Brynna asked her brother. He had been accepted into a west-coast college and had received a couple of small grants, which would help. Brynna

had done as much as she could to help with tuition, especially since Dev had been paying her school loans—with the agreement that she'd pay him back.

Her youngest brother nodded. "I got it all mailed."

"I suppose I need to arrange my schedule so we can drive out there and look at the dorms," she said.

"Dev is flying me out next week to look at an apartment and to find a part-time job," he replied, the information catching her by surprise. "He is so cool."

She looked at him in surprise and concern. "Tuck, the dorms are more affordable than an apartment, especially in California."

Besides, she was worried about him being on his own, so far away from home. She'd feel better if he was living on campus.

"I might find someone to share the rent with when we get there. There will be notices posted in the registration building. Where is Dev, anyway?"

Brynna glanced at her watch. "I don't know."

Just then a siren split the silence. Down the

street, Rumor's only fire truck could be heard leaving the station.

Chandler jumped up and grabbed Tuck's hand. "Let's go see!"

Chapter Five

Melanie forked the steaks onto a platter. "I'll take these in first, then join you out front."

Brynna followed the boys to the end of the driveway, where they could watch as the fire truck turned onto the dirt road leading toward Logan's Hill. The sky in that direction was dark with smoke.

"That looks really close," Tuck observed, voicing Brynna's own silent alarm.

"We could sure use some rain," Melanie said, coming to stand beside the others. "This drought is getting serious."

"News said there was a major storm front

on the west coast, but it will probably blow out before it reaches us," Frank said from the doorway, where he, too, studied the sky.

A sleek, black sports car pulled into the drive behind Brynna's, and her brother Kurt got out and joined them.

Brynna gave him a hug. "I haven't seen you for a while. Staying busy at the drugstore?"

"Always. I'm taking an online class, too, so my time's at a premium."

"What's the class?"

"Music appreciation."

Brynna smiled. Kurt was practical and had excelled at math, but he had a creative side and had composed music since he'd been in junior high. "Still play that guitar we found at the hock shop? You must have been in eighth grade."

Kurt grinned. "Nothing wrong with it."

Back inside, Frank took a bowl of salad greens from the refrigerator and they all sat at the dining room table, Devlin's absence glaringly obvious.

Static burst from the police scanner, followed by a brief conversation between the truck and Reed Kingsley, the local fire chief.

The fire truck had been dispatched to Logan's Hill, outside town.

Brynna's pager went off then, and she groaned. "Not already."

She dreaded relying on the skills of her one ER rotation, but she was the only local doctor. Rather than the hospital, however, it was Dev's number that appeared. "It's Dev," she said and got up to retrieve her phone from her purse in the other room.

He answered on the first ring. "Brynn?"

"Dev. Where are you?"

"Stuck in Washington. There's a serious thunderstorm right now, and I'm grounded for at least another three hours."

"Washington," she said, irritation lacing her tone. "You're supposed to be in Rumor. At the dinner table with the family right now. It's Tuck's birthday party."

"I didn't forget," he said. "I can't help it if the weather turned against me." Static crackled as if to emphasize his logic.

"You're incredible, blaming the weather for your lack of planning. You might have thought ahead before leaving for Washington. You didn't tell me you were going."

"I didn't plan to. I had a chance to pick up a part for *Sky Spirit,* and the weather service didn't predict anything like this. I know you're disappointed. I had every intention of—"

"If you intended to be here, then you should have stayed and not flown off when you knew we had plans."

"I had plenty of time."

"Or you just didn't care whether or not you got back in time."

"Brynn, I said I was sorry. What more can I do now?"

"Sorry doesn't fix a thing. You should have stayed. My whole family is here—except you—and my parents, of course. They never show up for anyone's birthday, either."

"That's not fair."

"Isn't it? My steak's getting cold. I'll see you when you get around to coming home." She turned the phone off and tossed it into her purse.

Seeing her face, Melanie asked, "What did he say?"

Brynna took her seat. "He's grounded in Washington."

"I'll bet he'll really be grounded when you get ahold of him," Tuck said, jokingly.

"I'm not his mother," Brynna replied, not amused. "He can do whatever he da—" She glanced at the younger boys and picked up her fork. "*Darn* well pleases."

After a few minutes of stilted conversation, Brynna lightened her mood for the sake of her little brother's party and they finished their meal. After the dishes were done, Tuck opened his gifts, finding practical things, like laundry bags and towels from Melanie, an alarm clock and a Game Boy game from Kurt, and Brynna had purchased a laptop computer as a gift from herself and Devlin.

Tuck's eyes lit up. He discarded the packing, plugging it in and figuring out how to use it. Within minutes he had it connected to the internet and was showing the boys children's sites and places to download games.

"This is way cool, sis," Tuck told her and gave her a hug. "Now I won't have to go to the library or borrow someone's PC. Thanks."

"You're welcome. Remember, there's a word-processing program in there for your assignments, too."

He grinned. She had always been the one to enforce homework and study time. Thank goodness, because he'd earned scholarships,

just as she and Kurt had before him. Melanie was the only one who hadn't been interested in school or college. She'd always single-mindedly wanted to get married.

Melanie sliced cake and Brynna scooped ice cream, Brynna was just starting to eat her portion when her beeper pulsed at her waist. Her pulse raced at the thought of Dev paging her, but this time it was the clinic. Brynna called to discover a fireman had been brought in with minor burns.

"What's going on?" she asked Rae Ann.

"A fire started on Logan's Hill," her friend replied. "It's spreading through the forest."

"Oh, no."

"And there's more bad news."

"What?" Brynna asked.

"Firefighters found two partially burned bodies where the fire started. So far, they haven't released any names. But you're the doctor on call."

"I'll be there."

The firefighter wasn't badly injured. After treating and releasing him, she drove home to an empty house. The spreading fire was a scary situation. She felt vulnerable and alone, and told herself her hormones were getting the best

of her, because she never felt this way. When midnight rolled around, Dev had still not returned and she finally fell into a restless sleep.

Dev slid on his sunglasses against the June sun and studied the smoke rising from the horizon where firefighters still fought the blaze that had started the night before. Logan's Hill was a good fifteen miles from the Holmes Ranch, so to be visible from here, the fire must be a serious threat.

He turned to unload cartons of new salt holders and grain feeders from the bed of his Ford Lariat pickup. Colby had decided that it was time to get the barn in shape and update its features before hay had to be cut and cattle rounded up come late summer and fall.

Unconsciously, Dev wondered if he'd still be working the ranch when fall came. So far the cowboy life suited him well. He'd learned a lot about training and caring for the horses, as well as the everyday tasks, and he was comfortable with the job. But the call of the wide-open sky was a lure he couldn't resist, and when the itch to fly hit him, he had to take a few days off and scratch it. Did that make him irresponsible?

In the four days since his wife had blown

him away with the news of her pregnancy, he'd been thinking a lot about responsibility. And after last night's fiasco of missing Tuck's birthday and getting the cold shoulder when he'd seen her this morning, he wondered all the more.

After stacking all the cartons inside the barn, he hung his hat, flipped open his pocketknife and opened the boxes. It took several minutes to find the proper tools and set about installing the feeders in the stalls, and the task gave him ample time to think.

He'd never considered himself irresponsible. But then, he didn't have many responsibilities. He had attorneys who handled his investments and paid his taxes. He showed up for an occasional stockholders' meeting and had to sign papers and approve decisions, but other than that, his time was his own. He didn't want any part of his father's business, even though he'd taken a lot of flack for not joining his father and older brother.

Over the past few years, he'd tried his hand at the lumber business, construction and now ranching—all outdoor jobs. It wasn't that he hadn't found anything he liked; it was that he liked everything and wanted to try it all.

But a man with a kid needed to be solid and dependable—needed to be there at all times. A trickle of perspiration rolled down his temple. Dev removed his shirt and used it to wipe his forehead. The role of a father was the last one he'd ever expected to fall into. Sure, he'd thought that someday he and Brynna would have kids...but that time had been far away in his obscure future—not in just thirty-two short weeks!

He was barely getting the hang of being a husband, let alone a dad to a small needy human being. The mere thought frightened the wits out of him. How could Brynna accept unexpected parenthood so serenely?

She knew what she wanted, he realized, and what she wanted included her medical career, a husband and a family. He hadn't known he'd wanted a wife until he'd met her. And once he had, there hadn't been a doubt in his mind that she was the one.

Maybe once he saw their baby—once the kid was real, he'd feel the same. He would know their child was what he wanted, too.

He'd thought they were going to have a couple of years to play at marriage and be newlyweds. There was so much he wanted to share

with her—to show her—places she'd never been. She'd worked her way through medical school and had sacrificed for her brothers and sister, and she deserved some time to enjoy life. He could give her that.

Dev paused with his hand on a stall gate, realization flooding over him like a bright light. His wife wanted a family. A baby. He had already given her that. A completely male sense of pride accompanied that thought. So be it. Maybe parenthood was happening sooner than he'd had time to plan for, but it was happening, so he could appreciate that. He could be happy.

Brynna had seemed quiet and withdrawn the last couple of days, undoubtedly because of his reaction. He'd disappointed her. On top of that, he'd blown it by not showing up for Tuck's party. She had a right to be mad.

She had to work late tonight, pull her Saturday-night shift at the clinic, but he would fix a late supper and surprise her with something special. He imagined her pleasure and her smile and knew everything would be okay. It had to be. The rift between them these past few days was unbearable, and he meant to fix it.

He'd finished turning the last screw and was

filling the salt holders when a ringing sound caught his ear. Remembering he'd left his cell phone on the seat of the truck, he hurried outside. Brynna often called him when she had a few minutes, and he didn't want to miss her call. The number on the caller ID indicated Rumor Family Clinic. "Hey, sweet thing," he said into the phone.

"Thanks," a voice replied. "But this is Rae Ann Benton. We just put Brynna in a bed and are getting ready to do an exam and an ultrasound."

Dev's chest felt like a horse had kicked it, and he struggled for a breath to ask, "What happened?"

His imagination conjured up all kinds of accidents and confrontations with unstable patients.

"Can't say for sure yet, but it looks like she's at risk of losing the baby."

Dev's heart dropped to his feet.

Chapter Six

"I'll be right there." Dev tossed the phone down, shrugged into his shirt and vaulted into the driver's seat. He paused with his forehead on the steering wheel for a minute—collecting himself? Praying?

"Dev?" Ash McDonough, a ranch hand, paused in leading a horse toward the barn, halting the animal beside the truck.

Dev sat up and started the engine. "Tell Colby I had to go into town. I'll call him."

"Everything okay?" Ash asked. "Is this about the fire?"

"No, it's my wife. I don't know if every-

thing's okay." The truck left a dust trail all the way down the drive. This was his fault because he hadn't been more supportive. And he'd upset her last night. No, that was nuts. Everything was going to be all right. Brynna wanted this baby more than anything, and nothing was going to happen. He wanted this baby, too, he realized, and panic made his heart hammer. It would be okay. Brynna was at the clinic. They would know what to do. She would know what to do—she was a doctor!

The drive was interminable—when he finally reached the clinic and parked haphazardly in a tow zone, he shoved open the glass doors and ran to the desk. After being directed, he hurtled past nurses and carts to the room indicated. Brynna was lying on a bed behind a green curtain, still wearing her scrubs, an IV in the back of her hand.

Dev rushed to her side and placed his hand on her knee which was covered by a thin white blanket. "Is everything okay?" he asked.

A tear squeezed from the corner of her eye, and she pressed her pale lips together before saying in a shaky voice, "No."

Heart thundering, careful of the needle in her hand, he rested his palm on her arm. "Tell me."

"I'm losing the baby, Dev."

Oh, Lord. Dev was stunned speechless. Why? Why had this happened? A million thoughts tumbled for prominence in his head, the one first and foremost being her devastation at this loss. "Can't they do something?"

She shook her head. "My cervix is dilated, and the ultrasound showed the—" she stumbled over the word "—fetus is not alive."

She wiped tears away with her other hand. "This early in pregnancy, it's known as spontaneous abortion. Sort of a natural selection process, probably a chromosomal or genetic abnormality. Or it's possible my body didn't produce adequate hormones or that I had an immune reaction to the embryo."

Dev listened to her medical explanation, understanding it, and yet not relating the terminology to the baby they'd been expecting. "I'm so sorry," he said softly, inadequately, his mind numb.

Her lower lip quivered, and he leaned forward to hold her where she lay. She wrapped her free arm around his neck and hugged him tightly.

"We'll get through this," he assured her, feeling helpless.

"I know." Her words were muffled against his damp shirt. "It's just...no matter how professional I try to be..."

"You don't have to be professional," he told her. "It was our baby." He leaned away to look at her and smooth her hair from her face.

She laid her head back against the pillows and blinked up at him, tears on her lashes. God, it hurt to see her like this.

"I thought we'd have a baby for Christmas," she said. "I was going to make stockings for the three of us."

An ache lodged in Dev's heart and he wanted to shed tears with her. He didn't. He forced himself to be the strong one. He tried to think of something—*anything*—to comfort her. "We'll have another baby," he promised.

She nodded, obviously uncomforted, and it had been a lame attempt anyway. The idea of a baby had begun to grow on him, and if he felt this awful—as if a knife was twisting his guts—she must feel worse. He felt so bad—for her and for him, and in desperation he sought words to comfort her, to make her see beyond this tragic moment. He had to fix this.

"We have our trip to Kenya planned for next spring," he reminded her. "Remember

our safari flight? What would we have done with a baby? We have so much we want to do. This way, we'll be able to do all the things we planned, and we can always have a baby later."

As soon as the stricken expression crossed her face, he knew he'd said the wrong thing. Dread encased his heart and he wanted to bang his head against the nearest wall for his stupid blunder.

She looked at him with hurt and disappointment so deep, he knew it touched her soul. He was an idiot. "*You* want to do all those things, Dev," she said, "I *don't*. *I* wanted this baby."

He couldn't think of a word to say around the size-twelve foot in his mouth. He opened and closed his lips, working on an apology. "I wanted this baby, too," he said at last.

"I want you to leave," she said, closing her eyes and turning her head away. She didn't believe him. How could she?

"I want to be here with you."

"I'm sure you'll find better entertainment for the afternoon," she replied sarcastically. As though all he cared about was having a good time.

Unfair as it was, the barb hurt.

"Just leave me alone," she added.

"How long will you have to stay here?"

"Just long enough to make sure the—miscarriage is complete." Her voice trembled. "I'll go home after that."

Dumbfounded, cursing himself for his inadequacy, he took a step back, but said, "I'll wait outside."

"I don't want you to."

The ache in his heart widened to a chasm, and he unconsciously flattened a palm over it in disbelief. She was hurting. But she was shutting him out. He was in pain, too. Couldn't she see that? Hurt turning swiftly to anger, he spun on his boot heel and stormed away.

Outside, the Montana sun beat down on his head, and he wondered absently where he'd left his hat. He stood beside the truck for a minute, collecting himself, wondering where to go, what to do. His world had been shaken—to its very center—and he had no idea what to do to fix it.

Brynna stared at the ceiling and fought the sobs that threatened to burst from her. If she started crying, she feared she'd never stop. They would have to sedate her and they'd send for a counselor. She knew what was wrong

with her, and she knew full well what she was experiencing. At Dev's words, the full impact of her husband's character had washed over her in a sickening wave.

His reaction to her pregnancy had been more than a disappointment. But his reaction today had broken her heart. He'd been relieved! A weight had been lifted from his shoulders. Anything that prevented him from having a good time was a burden—like a baby—like *her*. And she didn't want to be that burden. If he didn't want to settle down and make a family, she wasn't going to beg him.

Rae Ann appeared and took her blood pressure, her calm professional touch comforting Brynna in a way Dev's hadn't.

Brynna hoped this ordeal would be over soon.

By six that evening, she left the clinic and Emma drove her home. It had been embarrassing to tell the older woman that she'd sent Dev away, but she'd had to in order to keep Emma from calling him to come get her. "You take a few days off to collect yourself," Emma told her, without expecting an explanation. "Do as Dr. Dominic advised."

"I'm fine. I'll be able to come in."

"You may be physically okay, but emotionally you need some time. Trust me, I know."

"This has happened to you?" Brynna asked.

Emma nodded. "Twice."

Early miscarriage was common and many of Brynna's colleagues believed that every woman had at least one during her reproductive years, but that didn't make the reality any easier when it was personal. "Maybe I'll stay home for a couple of days."

"You do that." Emma parked in the drive.

Brynna stared at the pickup in front of the garage and finally opened the door to get out. "Thanks again."

She entered the house, where several lamps were lit and the stereo was playing softly. Dev came from the kitchen and stopped when he saw her. "You okay, Brynn?"

She nodded, laying down her bags. As okay as could be expected, considering she'd lost a baby and a dream in the same afternoon.

"I fixed something I could warm up easily."

She had smelled the food, but the thought of eating didn't appeal to her. "I don't want anything."

"You should eat."

She looked at him. He cared about her. He just didn't have the least inclination toward any of the things she held dear. She'd made a big mistake in marrying him, and she could no longer deny it. The truth had finally caught up with her, tackled her and slapped her in the face.

"Here." He moved to where he'd prepared a cozy-looking nest of sheets and pillows on the sofa. "Come put your feet up."

The rigid control she'd always had over her life had slipped so dangerously, Brynna didn't know herself anymore. Ever since she'd met this man, she'd made bad choices, illogical choices, and that frightened her. She was losing everything. Control. Patience. Direction.

She'd lost her baby, and life had never seemed so bleak. But it would get worse. With what she had to say next, she would lose the man she loved as well. But she had to be honest and save herself. Her heart was already broken, so there was nothing more to lose. What could feel worse than this?

Their relationship would never work. Deep down she'd known it from the very beginning. It had taken this day to make her face the cold hard fact.

Brynna took a deep breath and met his eyes. From somewhere deep inside, she found the courage to say what she had to.

"Dev, I need you to leave."

Chapter Seven

Devlin straightened and slowly turned to look at her. "Where do you want me to go?"

"I don't know. Fly somewhere. Go wherever it is you go when you're having a good time. Just don't stay here."

"But this is my place, here with you. I don't want to go anywhere."

She studied him. He'd showered and changed since she'd seen him at the hospital. Clean or dirty, he was the most devastatingly handsome man she'd ever seen. Just looking at him touched her heart, spoke to her woman's soul and weakened her sensible resolve. She'd

let the physical things, like his looks and her attraction to him sway her for the last time. "Don't you?"

"No. I don't."

"I think you should pack your things and go."

"Pack," he repeated, staring at her now. "Move out? You want me to move out?"

"Yes."

His posture changed and his expression shuttered. "Brynna, what in the hell have I done to tick you off like this?"

"I'm not mad. I've just stopped fooling myself and now I know that this is not going to work."

"*What's* not going to work?"

"Us. Our marriage."

He faced her squarely. "It was working just great until now. Suddenly you've got this attitude, and I can't do anything to please you. I know I say and do the wrong things, but give me a break. I'm only human. I said the wrong thing this afternoon."

"It was *not* working great until now," she argued. "You were just blind to the fact that it was all one-sided. We don't want the same things. You want to fly whenever the whim

strikes. You want to play at being a cowboy. You want to go to Kenya. I've always known what I want and a husband and a family are part of it."

"I want a family, too," he said, and it was plain that he was working to keep his voice low and level. "I never said I didn't."

"Oh, really. Well, you sure didn't jump for joy when you found out I was pregnant. And when I lost the baby, all you could think of is that you're free again."

"That's not true, I—"

"I'm tired of being a ball and chain, Dev," she said wearily. "I can't travel with you because of my career, and I don't expect you to stay here."

"So far it's worked. I've taken a few trips, but—"

"No, it's not working. Not for me, anyway. If you won't leave, I'll pack my things and go. I can stay with Melanie."

"No. I don't want you to." He hooked a hand on his hip and stood in thoughtful contemplation, not looking at her.

"You'll leave?" she asked, hating that she was saying this, that she'd brought all of this upon both of them because of her weakness.

He turned his green gaze on her then, and she steeled herself against the foolish love and desire she felt for him. She would not back down now.

"If it's what you really want," he said, his voice a gruff sound she'd never heard before. "I'll go."

She moved past him to sit in the spot he'd made on the sofa.

"But you shouldn't be alone," he added. "Let me stay here with you tonight."

If she gave in to him, she'd always be giving in, never have what it was she really wanted. She didn't want to be alone. But neither did she want to be reminded of the mistake she was paying for. She'd made the decision, now she was going to carry it through. "I'll call Melanie," she said. "She'll come over."

"Can we talk about this after you've rested?" he asked.

"I don't know what there is to talk about," she replied.

Anger flashed in his eyes and the set of his jaw showed his restraint. "About *us*. About our marriage," he replied tersely.

"We should have talked about that before,"

Brynna said, having made up her mind and determined not to let him change it.

If he'd paid more attention, he wouldn't have been blindsided by her resolve now. She'd fooled herself into thinking her love for him could make up for their differences. This week she'd awakened to the truth, even though it had taken something horrible to snap her out of her delusion.

Hurt and angry, and at a loss for a way to repair what had happened, Devlin headed for the stairs. He jammed clothing, shaving gear and a few personal items into a flight bag and carried it down to the foyer. From the closet, he added his jacket and a couple of Stetsons to his belongings, then stopped with his hand on the doorknob.

Pride—or hurt—kept him from turning back to look at her. He deliberately opened the door and exited their home, pulling the door closed behind him with a final click. He stood on the stoop beside a bucket of lushly blooming white geraniums. He should probably remind her to water them; he'd done it every evening.

The hell with the geraniums. Dev stepped off the stairs and walked toward his truck. Away from her, from their house.

This was his home, too. She'd insisted on paying equally when they'd purchased it only two short weeks after their marriage. Her financial help was unnecessary, but she felt the house belonged to them equally if they shared the cost. Her apartment had been too small for both of them, and they'd wanted a bigger place of their own. This had been an ideal choice, new enough and small enough to not require extensive work from two busy people.

Dev tossed his things onto the passenger seat and turned to study the row of trees they'd planted along the property line, the landscaping they'd done on the weekends she'd had off, and the leafy fronds of the ferns she'd insisted they leave along the shady side of the garage. This was *their* place…and he was leaving. What choice did he have? She would move out if he didn't, and he didn't want her out of her home at this time. Not at any time, but especially not now that she needed rest and comfort.

He was a first-class screwup, so he undoubtedly deserved her anger. Did he deserve to be sent packing? Maybe so. When she'd needed him the most, he'd said and done the wrong thing.

But starting the engine and backing out of the drive, he thought over the words she'd hurled at him. He wanted to "play at being a cowboy" she'd said, and he winced at the remembrance. That had stung. He'd done a damned good job at the Holmes Ranch. He enjoyed the work. Was the job insignificant because he didn't need the money? Plenty of wealthy people worked.

Did she resent the fact that he'd never lived hand-to-mouth? A lot of people seemed to take issue with that, but he couldn't change the facts. If she did resent his financial freedom, she was being pretty stinkin' shallow.

Sure she'd worked and sacrificed, but did that make her better than him? More deserving? Was her work of more value because she knew what she wanted, and he was still trying to figure that out? Sure, her profession was valuable, but would it have been any less so if she'd had the money for her education readily available?

Headed for the ranch, Dev stewed over the situation until he'd worked up a full-blown temper. She had a lot of nerve belittling him and holding his inadequate words against him. She'd come to her senses in a day or two and

then he'd show her how to accept an apology gracefully.

He slowed the truck to a safer speed, and with each passing mile, he prayed he was right—and that she would come to her senses. No matter how long it took.

The following day, news on the fire spread through the hospital at the speed of light. The two bodies found on Logan's Hill had been identified as those of Wanda Cantrell, wife of Rumor High School's science teacher, and Morris Templeton, the attendant from the gas station and convenience store right outside of town. As of yet, Wanda's husband, Guy Cantrell, was still missing, and no one knew where he'd gone. Suspicion ran rampant.

Brynna made rounds, then left before noon to go home and rest. Melanie was waiting on her front steps. "I can't believe you went to work. You wouldn't let me come over last night, and today I show up to find you gone."

She wrapped her arms around Brynna and hugged her soundly. Immediately, tears smarted behind Brynna's eyelids, but she blinked them back and pasted on a smile for her sister. "I told you, I'm okay."

"Well, you lied. You're hurting. Where is your husband anyway? He should have stopped you from going to the hospital this morning."

Brynna unlocked the door, and Melanie followed her into the cool interior of the house. Brynna placed her keys on the hall table, her bag on the floor and took a fortifying breath. "He's gone. I asked him to move out."

Melanie stared at her. "What? You're the levelheaded one, the pulled-together sister. What did you do that for?"

Brynna did her best to give Melanie the condensed version of everything that had led to her realization that marrying Dev had been a mistake. She was still trying to understand it herself, so explaining it was difficult. Mel didn't require much of an explanation, however; she seemed instinctively to understand Brynna's hurt.

"Sit down and I'll fix us some lunch," her sister said.

Brynna changed her clothing and washed her face before complying and settling onto the sofa where the blankets and pillows Dev had arranged still remained.

A few minutes later, Melanie handed her a

plate holding a sandwich and sat across from her. "At least you didn't wake up one day and discover you'd married Archie Bunker," she said, taking a bite of her tuna salad.

Relieved that her sister was talking about her own problems as usual, instead of questioning her, Brynna asked, "What do you mean?"

Melanie set down her plate. "The man has the most irritating habits. Sometimes I think I'll scream if I don't get away for a while. And he's got this macho idea that I should stay home while he brings home the money."

"I thought you liked staying home with the boys."

"I do, but they're getting older—they're not babies anymore. I'd like a part-time job, just to get out of the house for a little while. Frank won't even discuss it."

"I remember when you were tickled to quit your job at the school cafeteria to stay home and have babies."

"I should have finished college," Melanie said. "Like you. You told me to finish college, but I was in a hurry to get married. You were the smart one, waiting like you did."

"I don't know how smart it was to get mar-

ried at all, in my case," Brynna replied. "I'd never done an impulsive thing in my life before Dev. And now looking back, I can see it was insane, for crying out loud." She set her own plate aside and brought her hand up to her head. "I barely knew him."

"I guess you knew enough to fall in love with him."

Brynna's eyes filled with tears, and she quickly swiped them away.

"The difference is, Brynn, Dev knew you had a career, and he had his planes, and the two of you compromised to be together, right? For Frank, I'm just the woman who had his kids and takes care of them. To him, there is no other me. But there is. She's just stifled inside somewhere."

"Don't you think most mothers of young children feel the same at some point or another?" Brynna asked. "Children take time and energy, and you still have to work on your relationship with your spouse. After the kids are gone, you'll have each other, and you don't want to weaken what you had to start with."

Melanie picked up her sandwich and ate a few more bites.

"You need to get together with friends who have young children like you, Mel. It helps to know you're not the only one going through this stuff." Her grief counseling and psychology classes hadn't been for nothing. She just wasn't much good at applying the lessons to herself.

"I do. Most of the time they talk about coupons and what's on sale at MonMart. But they all seem more satisfied with their boring lives and their husbands than I am. Frank seems so unreasonable sometimes. Take this argument over me working. I think the real reason he refuses is that he doesn't want to take care of the boys while I work for a few hours."

"Has he said that? Frank loves those kids."

"No. Not in so many words."

"Well, why don't you ask him if that's the real problem? Ask him out on a date, where you can be alone to talk and tell him how you're feeling. You can bring the boys over here."

"Are you sure you want to keep them? You're working two jobs—and you've just gone through an emotional loss. You're having your own personal trauma with Dev."

"I adore those guys, of course I want them.

I need something to take my mind off my own problems for an evening. It'll be good for me."

Melanie gave her an appreciative smile. "You're the best sister in the whole world, you know that?"

"Yeah, I know."

"I'll ask Frank, and we'll set a date. I'll call about your schedule."

"Perfect."

"Now, what about you?" Melanie asked, turning the tables. "Are you planning to talk to Dev about how you feel?"

"I've explained how I feel. Dev and I were never meant to be together in the first place. He has his life, and I have mine."

"There's always compromise."

"Not on his side, there's not. I don't want to be the only one holding a family together."

"Like you did for ours, you mean," Melanie said softly.

Brynna looked into her sister's eyes, knowing she understood. "Like I did for ours."

Dev parked in front of the house and turned off the headlights. The interior of the two-story home was dark, except for a dim light glowing from the living room. The television probably.

He'd let two days go by without phoning her. He'd gone over their conversations, over the things he'd said and done, and knew she had every right to be mad. Ever since he'd brought up the Kenya trip, he'd wished he could take back those stupid words.

His feelings fluctuated from angry to repentant and back again a dozen times a day.

He got out of the truck and approached the house. She was still his wife, and he still loved her. This was still his home. He touched the key to the lock, then paused, reconsidering.

After thinking better of opening the door, he rapped his knuckles against the wood… and waited.

Chapter Eight

The porch light came on and the lace curtains on the door fluttered aside. The lock turned and Brynna opened the door. She was wearing a little white tank top and black sweatpants, and the outfit made her look small and vulnerable...and sexy as always. God, he missed her.

"I wanted to see how you're doing," he said. "May I come in?"

"You could have called," she said.

"But I didn't, and I'm here now, so are you going to let me in?" He took off his hat and stepped forward.

Brynna opened the door wider and backed into the foyer with a sweeping gesture of one arm.

Dev dropped his hat on the hall table as he always did and moved into the living room. The television was playing, and it was obvious she'd been lying on the bedding he'd arranged on the sofa the other day.

"Have you been going to work?" he asked.

"Half days so far. I do rounds and come home. I haven't been to the clinic for two days."

"That's good." He took a seat on an over-stuffed chair.

Brynna sat on the sofa and tucked a pillow against her chest, her arms encircling it, as though placing a barrier between them. She cast him an uncertain look.

Dev wanted nothing more than to join her on the sofa and pull her into his arms—hold her until the quaking inside him stopped. Fear had crept in around the edges of his anger and self-assurance. He was starting to think maybe she was serious. And that scared the hell out of him.

"Are you feeling okay?" he asked.

She nodded. "I'm fine. Really."

She looked a little pale to him. "Sleeping?"

Brynna shrugged a slender shoulder. "Not so great."

All the things he wanted to say were jumbled in his mind now. Sorting through them, Dev flattened his palms on his knees, then flexed his hands nervously. He noticed she was watching his hands and forced them to lie still. "Brynn, I'm sorry for saying what I did. I knew it was stupid as soon as I said it. But I just wanted to say something that would make you feel better, and I was groping for something. Anything. I was out of my depth."

"You said you were sorry," she replied.

"And you said sorry didn't fix things. Well, I'm here to fix things. Just accept my apology."

"So you can feel better? Okay. I accept your apology."

He scanned her face to confirm what she really meant, hoping she had truly forgiven him, but was skeptically hesitant to believe it. "So you forgive me?"

"Yes."

He almost breathed a sigh of relief.

"But forgiving you doesn't change the situation. What happened, and what you said, was a reflection of what's on your heart and

your mind at all times, don't you see that? You weren't excited about a baby, Dev. To you it was an accident, an inconvenience."

"No, it was a surprise—okay, all right—a *shock,* I won't deny that. But the idea grew on me. I was okay with being a father. I was planning to tell you that when I got the call from the clinic. I never got the chance."

Brynna looked into his eyes. She didn't believe him.

"Too little too late, Dev," she said, the dullness in her voice breaking his heart, and terrifying him to the bone.

Without giving her a chance to say anything more—anything worse, like telling him she wanted a legal separation—or a divorce—Dev jumped up from the chair and moved toward the door. "You're shutting me out when I could be here helping you, sharing this," he said gruffly. "Don't throw this back at me later, too."

He grabbed his hat. "I'll call you in a day or so after we've both thought it through and we'll talk again."

He closed the door behind him and loped out to his truck. Starting the engine, he slammed it into gear and drove away. Away from his

home. Away from his wife. Away from everything that had ever meant anything to him.

At the ranch, he parked and stood gazing toward the eerie haze in the dark sky where the fires still burned. His stomach churned. If he'd eaten any supper, he would have thrown it up.

Dev was so absorbed, he didn't hear Ash coming up beside him until he spoke. "Just came back from there to catch some sleep. It doesn't look good. They've called in volunteers from all over."

Ash was one of Rumor's volunteer firemen, so of course he'd be in the thick of things. Dev changed the focus of his thinking to ask, "So what's happening?"

"Did you read tonight's edition of the *Rumor Mill?*"

"Nope."

"Seems that Guy Cantrell is suspected of murdering his wife and her lover up there." The cowboy offered him a can of beer.

"Thanks." Dev popped the top and took a long swallow. "The gas station guy was her lover?"

"They have a witness who claims he knew the two were having an affair. Investigators found evidence near the bodies. Pieces of

a shirt, a ripped piece of what looks like a canvas backpack, some broken glass and footprints."

"Sounds like one of those crime investigator shows."

"Yeah, and since the mayor married Chelsea Kearns, we have our very own forensics expert right here in Rumor. Evidence makes it look like Guy probably caught 'em together."

"And this teacher is missing, right? You'd think he'd stick around and clear his name," Dev commented.

"Sometimes saying you're innocent doesn't get you very far," Ash commented.

Dev glanced at him. Ash was on parole for a crime he claimed to have been set up for. He'd done five years in prison and was about as cynical as a man could get about not only the system, but life in general. "Must be a terrible feeling to know no one believes you."

Ash shrugged. "You live with it."

Dev had to admire Ash for coming back to Montana to make a life for himself and make amends with his sister. His determination to prove himself came through in everything he did.

"It's none of my business," Ash said, "but I

can't help wondering what you're doing staying at the ranch again."

Dev leaned against the fender of his truck and crossed his ankles. Heat radiated from the engine, but didn't warm the numb coldness inside. "I'm a screwup," he said. "I missed a birthday party. And I said some really stupid things. For her it's deeper than that. She's—" He choked on the words and started over. "Brynna's sorry she married me."

"Doesn't sound like anything you can't fix."

"Believe me, I would if I knew how."

"What got you together in the first place?"

"Mind-blowing sex."

Ash chuckled. "I was gonna suggest you try whatever it was you did to win her over, but if it was sex, that's probably out of the question since you're not sleeping there."

"She's not exactly receptive right now."

"Well, if sex came first, maybe you need to try a little romance now."

Dev studied the hired hand, thinking over his suggestion. "Maybe you're right."

Brynna threw herself into her work with the same determination she'd always relied upon. The demanding job at the hospital and

her volunteer work at the clinic eased the pain of her loss and didn't allow her time to think about Devlin. In theory anyway. That's the way it would have been if fate hadn't conspired against her at every turn.

One of her patients, Susannah Kingsley, had a morning appointment that Tuesday, and Brynna greeted her warmly and asked a few questions before examining her.

Several years prior, Susannah had experienced a tubal pregnancy, which had required the removal of an ovary and a fallopian tube. When she'd first come to Brynna after her marriage, seeking help in getting pregnant, Brynna had discovered an abnormality on her remaining fallopian tube. The young woman had been devastated, and Brynna had been skeptical that surgery would correct her infertility.

But after Susannah was dressed, Brynna let herself into the exam room and sat on a stool across from her. This was one of the most rewarding parts of her job. "Susannah, you're pregnant."

The young woman's blue eyes filled with tears of joy, and she smiled the smile Brynna lived for: that of a mother seeing her child for

the first time; the smile of a woman discovering she was expecting a much-wanted baby.

"Oh my gosh!" Susannah stood and pressed her hands to her cheeks. "Oh my gosh!" She touched her stomach next. Reverently. "Is everything okay?"

Brynna was quick to reassure her. "You're healthy as can be, and I don't foresee any problems."

Susannah positively glowed. "Mei is going to be a big sister!" she said in awe.

The year before, thinking they wouldn't have children of their own, Susannah and her husband, Russell, had adopted a baby girl from China. "Thank you, Dr. Holmes! Thank you so much!"

She gave Brynna an impulsive hug.

Brynna laughed. "Well, I may have helped a little, but you and Russell did all the work."

"No. We couldn't have had this baby without you. He's going to be so happy. *I'm* so happy!" She picked up her purse and straightened her long red hair in the tiny mirror on the wall. "I can't wait to tell him."

"Congratulations, Susannah."

Susannah's expression changed immediately. She met Brynna's gaze in the mirror.

Her smile waned and her eyes widened. She turned and gave Brynna an apologetic look. "Oh, how thoughtless of me to carry on like that."

Brynna knew immediately that Susannah had heard the news of Brynna's miscarriage through the grapevine. "Not at all," she assured her. "You have every reason to be happy. I'm very happy for you."

"Well," Susannah continued, obviously wanting to express her sympathy, "I'm sorry about what happened with you. I know how it is to want a baby."

"I know you do. Thank you," Brynna said simply.

Susannah hugged her again and swept out of the examining room.

Brynna groped for the seat of the stool and sat. Grief pressed upon her chest, making it hard to breathe, to think. She rubbed her temple, where an ache had started. This was one of those crowning moments of her career, one of the days she worked for—the reason she'd gone to medical school. But her own situation wouldn't allow her to appreciate it as she should have.

Brynna made it through the rest of the day

by tuning out her own feelings and personal life and concentrating on her patients. At midday a bouquet arrived, a dozen long-stemmed red roses with a note that read simply I love you. Brynna arranged the flowers in a vase on the admissions desk and tucked the card into a pocket in her trousers.

When her shift was over, she drove to the clinic and put in another four hours. It was nine o'clock in the evening before she admitted she was avoiding going home to an empty house. When she stopped thinking about her patients, she was reminded of the child she'd lost…of the family she wanted. At the house, she undressed, pulling the gift card from her pocket. She studied Dev's handwriting, neat and crisp.

Her gaze moved to the unmade bed, no longer plain and uninviting; after their marriage, she and Dev had purchased a king-size bed with rich linens, a downy comforter and plump pillows, a perfect love nest.

A perfect *empty* love nest.

No longer able to hold back the devastating feelings of loss and disappointment and uncertainty, she staggered to the edge of the bed and let the tears fall.

Everything and every moment reminded her of the husband who hadn't shared her dreams. And each breath reinforced the fact that she was facing a future without him.

Chapter Nine

By Friday Dev had sent flowers, chocolates, a gold bracelet and perfume. The deliveries were becoming the talk of the hospital staff, and rumors had spread through town.

That evening Dev found lights on at the house, so he parked in the drive and rang the bell.

Brynna opened the door, looking pale and tired. "I wasn't expecting you," she said.

Children's voices chirped from inside somewhere. He glanced behind her. "You have company?"

Just then John and Chandler burst around a

corner and spotted him in the doorway. "Unca Dev!" Chandler shouted, barreling forward and John was right behind him.

"Hey, fellas!" Dev stepped in and Brynna closed the door behind him.

"Aunt Brynn said you was busy," John said.

"I worked at the ranch today," he replied, kneeling for their unreserved hugs. "What are you up to?"

"We're havin' a sleepover," John supplied. "Cool, huh?"

"Play Wescue Wangers with us," Chandler said in his determined manner and took Dev's hand, pulling him toward the family room.

Dev and Brynna exchanged a glance, and he gave her a penitent smile. "Rescue Rangers, eh? Who are we rescuing?"

"We're firemans," John told him. "We're putting out the tree fires, like on TV."

Dev joined the boys on the floor with the action figures and soon had a noisy rescue mission under way. She watched them for a few minutes, appreciating Dev's easy interaction with the children, and his genuine interest in them. They had accepted him into the family and given him an honored position of favored uncle, right beside Kurt and Tuck.

Brynna picked up discarded shoes, socks and the less fascinating toys, then took a few minutes to wash the supper dishes and get an evening snack ready. When she returned to the family room, Dev had become a tiger on his hands and knees and was snarling and growling while John and Chandler shrieked and ran past her into the other room.

Still in character, Dev pursued, and, minutes later, she could hear them upstairs, running and laughing. Brynna set the room to rights, replacing sofa cushions and pillows and getting a movie ready to watch.

Laughter grew near again, feet pounded on the stairs, and the boys were back, panting. "Where's Uncle Dev?"

"Not in here."

They tore back out of the room.

"Be careful on those stairs!" Curiously amused, she grabbed Dev's video camera out of the closet and followed.

Her barefoot nephews crept up the steps as quietly as a four- and a six-year-old could, and their excitement laced with hesitation made her smile as she videotaped their apprehensive search. John led the way, Chandler at his heels, as they tentatively peered into every

room. Chandler made a point of turning on each wall switch and flooding the rooms with light before they entered.

Just as they were tiptoeing toward the bathroom, the door to the hall closet burst open and Dev shot out on his hands and knees, growling.

Chandler shrieked and ran toward Brynna, his blue eyes round as moons. Brynna balanced the camera, while still trying to tape and not fall over. John jumped on Dev's back and wrestled him with an arm around Dev's throat. Dev pretended to choke and fell on the carpeted floor.

Brynna held Chandler close and felt his little heart racing against her palm. A second later, he jumped away and joined the fray on the floor. Dev laughed so hard, his face was red, and Brynna didn't know if the color was caused by his amusement or the choke hold John had around his neck.

She couldn't help laughing at their antics, especially remembering the look on Chandler's face when Dev had lunged out of that closet. She laughed until tears ran from her eyes, and she had to wipe them away to see through the viewfinder. She could probably

send this footage to *America's Funniest Home Videos* and win the grand prize.

Dev rolled over, both boys still glued to his shoulders. "Look there, it's Auntie Tiger. I think she has a snack ready for us. I'm hungry, how about you?"

John jumped to his feet and darted off, with Chandler following him down the stairs. Dev stood and held out a hand to Brynna where she sat, the camera in her lap. "Come on Auntie Tiger."

She took his hand and let him help her up before preceding him down the stairs. After assigning the boys seats around the coffee table, she gave them quartered sandwiches and slices of fruit and handed Dev a plate with a sandwich.

Chandler gulped his chocolate milk and burped. "'Scuse me."

John laughed and Dev grinned.

Chandler burped again. "My heart just keeps burping," he explained, one hand on the front of his T-shirt.

Dev cracked up at that, and before long, the three of them were holding a burping contest.

Brynna watched with amusement, then

started their movie. "Let's get them settled down, so they won't be too wound up to sleep."

Dev nodded. "Can I help put them to bed?"

She studied him briefly. "Sure."

"How did you get so lucky?" he asked. The boys had already become engrossed in Stuart Little's adventures. "Getting them for the night, I mean."

"Frank and Melanie needed some time together. Alone. I offered."

He placed the dishes and cups on a tray. "That was nice of you. They doing okay?"

"I'll do those," she said, reaching for the tray. "They're working out a few things."

"I don't mind." He moved the platter away from her reach and carried it toward the kitchen. She followed.

Dev rinsed the cups and put the tray away. He knew where everything went—it was his house, after all.

"I'll sit with them if you have anything you need to do," he offered.

She shook her head. "I don't. How about you? You didn't have any plans for tonight?"

"I planned to come see you."

She didn't say anything, just leaned back

against the counter and glanced out the kitchen window into the darkness.

"You got the gifts?" he asked, and nodded toward the bracelet on her wrist.

She moved her arm and studied the delicate piece of gold jewelry. "Yes. They're all lovely, thank you. But you don't have to give me presents."

"You're my wife. You won't let me be here. You won't let me...share things with you the way I'd like to. I just wanted you to know I care...that I'm thinking about you. That I love you."

Brynna closed her eyes momentarily, ineffectively shutting out his words. A warm touch on her shoulder surprised her, and the sensation rippled down her spine. She opened her eyes to find him in front of her. He slid his hand to her forearm, the sensation waking nerve endings and feelings alike. "How are you? Really?" he asked, concern in his voice, his eyes.

She was so needy for comfort, for release from the grief and regret and even anger she'd bottled up inside, that his concern was like setting a match to a fuse. His gentle familiar touch opened up every wound she'd unsuc-

cessfully tried to close, tore down defenses she'd methodically constructed and maintained for days.

The simple tactile display opened a floodgate of emotion. She wanted to tell him about Susannah. About how she felt and how much she hurt.

"Aunt Brynn, do you got any of those little fish crackers?" Chandler asked from the doorway.

Glad for the interruption, Brynna moved away from Dev's touch. What good would it do to voice those feelings? "I think I have a bag up here," she said, opening a cupboard. "Does John want some, too?"

She carried their crackers to them, refilled their cups and settled down to join them for the end of the movie. Devlin sat at the opposite end of the sofa, where Chandler eventually crept into his lap. From the corner of her eye, she glimpsed the scene: Chandler's chubby limbs and bare feet against Dev's long jean-clad legs; the child's relaxed fingers on the man's strong tanned arm; the trusting child and the ease with which Dev accommodated him.

Obviously, it wasn't children in general that

Dev had an aversion to. Did babies intimidate him? Or just the thought of being a parent and having to care for a child daily for the next eighteen or so years? With these kids he could have fun and then they went home.

When the show ended, Brynna ushered the boys upstairs and supervised their change into pajamas and the brushing of teeth.

"We didn't bring no books," Chandler said, a furrow between his eyebrows as Brynna was tucking them into the guest room bed. "We need a bedtime story."

"I'll tell you one," Dev said. "We don't need a book for one of my stories. You just make the pictures up in your head." He settled on the side of the mattress and began a tale.

Brynna stretched out on her stomach across the foot of the bed and watched the boys' faces as Dev regaled them with a story about a tiger who wanted to play baseball.

He had always enjoyed her nephews, and they adored him, as much as they adored Brynna's brothers. Seeing him with them like this, she couldn't help but admire his exuberance and playful spirit. Maybe he would have made a wonderful father. Maybe she had

misjudged him—and maybe he'd misjudged himself.

Chandler fell asleep first, followed only minutes later by his brother. Dev tucked them in and left the room while Brynna picked up clothing and turned out the light. She found him in their bedroom.

"I'm missing a watch," he said. "I think I left it in one of these drawers." Finding it, he turned to where she stood in the doorway.

The look on his face showed he wasn't thinking of that watch. What did he see when he looked at her? He placed the timepiece on top of the dresser and walked toward her.

Chapter Ten

Brynna looked away, so Dev wouldn't see the need his presence had wrenched up from the center of her being. She didn't *want* to be needy. She was the strong one, the person who took care of others and herself without help.

"Brynn, I miss you," he said gruffly. "All the things I thought meant something, don't mean anything without you. You're it. My foundation. I didn't even know it until…"

He threaded his fingers into her hair and placed his other palm along her jaw, bringing them so close she could see the brown flecks in his green eyes. "This thing we have is the

one thing that means something in my life. I'm scared that I can't fix it."

Brynna wanted nothing more than to fold herself against him, into him, take comfort and find security in his touch. She didn't want to think his words through or argue. She didn't want to think about anything. She wanted to feel safe. Loved. She needed the human sustenance he offered so readily. If only she could believe this was real and lasting.

He leaned toward her and she was eager to kiss him, press herself against his strong body and find solace in his arms. He kissed her so gently and reverently, her throat burned with reserved tears and passion. Brynna clung to him, released sighs of pleasure and consolation when he kissed her chin, her cheeks, her eyelids and pressed his lips against her neck.

Held tightly against him, she was safe and small and the world didn't exist. Nothing existed but the two of them and this burning, consuming, blanketing passion they shared. Through the fabric of his shirt, she stroked his back, his chest, impatient to pull the material away and find his skin, as warm and smooth as she remembered. He groaned at her touches, found the buttons of her blouse and pulled it

from her shoulders, then unfastened her bra and tossed it aside.

Over her shoulder, he switched off the light and closed the door while she pressed her face into his chest and kissed his skin.

He caressed her breasts, always so sensitive to his gentle stroking and the way he brought her nipples to hard peaks before taking them into his mouth. She urged him to do so now, and he guided her to the bed before carrying out her wishes.

Brynna stretched and writhed and returned the touches, kissing him until neither of them could breathe. Impatiently, she pulled him to her, eager for the pleasure and the closeness, enamored as always with her attentive lover. It was marvelous, this way he made her feel...

"Brynna, is it okay? We don't have to, I could just—"

"No, it's okay. I'm okay. *Now.*"

Dev slid into her, against her, and she wrapped herself around him to ride out the luxurious indulgence of his lovemaking. The experience was as incredible as always. All-consuming. Mindless. Pure earthy heat and sensation.

"You are a sweet, *sweet* thing." He mur-

mured praises in that seductive throaty tone that melted her bones.

When he tried to be gentle, she urged him to thrust harder, deeper. When he would have gone slowly, she demanded urgency. When he would have waited, she coaxed his climax, which provoked hers, and together they lay spent and breathing hard on the tangled sheets.

Brynna buried her face against Dev's chest and inhaled the smell of him, felt his strong arms around her, heard the beating of his heart. Minutes passed and his heart rate slowed. His breathing grew deep and even, indicating he dozed.

She was wide awake. And thinking back over what had just happened. This was exactly what had gotten her to this stage in the first place. Her mind-numbing, completely physical, totally sexual reaction to this man. She'd never been weak to temptations or distractions before she'd met him. She'd never stepped off the well-paved road to her goal until Dev, and now she'd been stupid enough to make the same mistake twice.

She wasn't comforted, she was confused. She was weak and embarrassed. Angry with

herself. And *scared.* Hadn't she learned the price of being impulsive? Regret welled up and brought tears with it. She *wanted* Dev, she just couldn't handle the uncertainty and the hurt of not coming first in his life. A sob escaped her.

"Brynn," Dev said sleepily, leaning up on one elbow over her. "It's okay, baby."

She shook her head against his shoulder.

He ran his hand through her hair, but she pulled away. "Go now," she whispered hoarsely.

"Brynn," Dev said. He reached for her.

She moved back, shaking her head, and pulled the sheets around her body. "No. Leave."

He cursed and sat up. "I'm damned tired of you telling me to leave."

She had nothing to say. Words were inadequate for what she was feeling...the regret, the shame... the loss.

He stood and fumbled in the dark for his pants. "What was this about, then?" he asked, frustration plain in his voice.

"It was a mistake."

Denim rustled. His belt buckle clanked. "No, burning the toast is a mistake. Taking the wrong highway is a mistake. Not this. Not

this, Brynna. The mistake here is you not giving us a chance."

He opened the door, allowing a dim light to silhouette his form.

"The mistake is me leaving."

And he left.

Dev was mad as hell now. And rightly so. She'd run hot and cold for the last week, and he was fed up with it. Plain fed up. Her words were all meant to drive him away. But her reaction to him, her responses, her *eyes* said differently. He was tired of her toying with him as though he were a puppet and angry that she didn't acknowledge that he was hurting, too.

Damn the woman!

With the following morning came an opportunity to fly an outfitter across the Rockies, and he accepted the offer with grim determination. The day away would give him time to think—or not to think—whichever the case would be, and the distance would keep him from making any more unwelcome attempts to patch things up with Brynna.

After checking with the National Weather Service, he filed a flight plan and told Colby his intentions.

"Work is slow around here, but I'll need you back soon," Colby told him. "Ash is planning to go south with the fire camps."

"I heard the fire wasn't contained."

"With a national park like Custer threatened, Modular Airborne Firefighting System has been called. The Kingsleys' cousin, Jeff Forsythe, should be on his way," Colby said.

"I won't leave you short for more than a day or two," Dev promised. "I just need air therapy right now."

Colby, used to Dev flying off at a moment's notice, wished him well.

Dev concerned himself with fuel and pre-flight instructions for his passenger and left the following morning.

Brynna heard from Jim Brenner, the pediatrician, who heard from his wife Kelly, who heard from Donna Mason, who ran the Getaway Salon and Spa, who heard from Tessa Holmes, Colby's wife, that Dev had flown somewhere. At least he wouldn't be a temptation if he wasn't knocking on her door and sending gifts, she reasoned.

The gifts had stopped abruptly after Friday night, however. Again and again she wondered if she'd overreacted. She felt safe in the house,

even though she was alone. Safe from the hurt and neglect and feelings of abandonment that her relationship with Dev brought on.

When she stepped back and rationalized, she could see that she'd treated him unfairly by welcoming his lovemaking and then rejecting all the feelings that came with it. Opening herself up to him frightened her so badly, she hadn't behaved sensibly. And she prided herself on behaving sensibly.

Could she salvage something—maybe leave them with a friendship—by apologizing? When he came back, maybe she could talk to him. She stopped at MonMart on her way home from the clinic, bought groceries and essentials, carried them into the empty house and put them away.

While a frozen dinner was microwaving, she sorted the mail. An envelope with an unfamiliar Nevada address caught her attention, and she slit it open with a paring knife while she leaned against the kitchen counter.

The letterhead was that of a law firm in Las Vegas. Brynna scanned the letter, addressed to both she and Dev, then went back to read the words more carefully, absorbing their meaning with a horrible sense of dread and disbelief.

She and Dev were being asked to join a class action lawsuit against a fraudulent minister who had swindled millions of dollars from several wedding chapels in Nevada. He had performed many weddings, all void—theirs had been one of them.

Chapter Eleven

The tongue-and-groove wood floor threatened to come up to meet her, so Brynna collapsed onto a chair and closed her eyes until the light-headedness passed.

A few minutes later, when she could see straight, when the room had stopped spinning, she found the letter on the floor and read it again.

She and Dev weren't legally married.

Their marriage had been a sham all along.

As if she hadn't suffered enough pain and humiliation, now this on top of it? And she'd thought things couldn't get any worse. She

couldn't let this news get out or everyone in Rumor—and soon enough Whitehorn—would know of it. The gossips would have a field day!

Brynna thrust her fingers into her hair and closed her eyes as if not seeing would make this go away.

What was she doing thinking about the gossips? What about how she felt? What about how Dev would feel? Would he see this as an easy way out of a sticky situation? There weren't even the strings of matrimony tying him to the earth anymore. He could fly off and be completely free.

Without noticing the microwave's insistent beep, she sat with her head in her hands. Her marriage was so much of a mistake, even God hadn't approved. And she had been thinking of apologizing for a little indecision! As if! Everything was such a mess now it could *never* be fixed.

If they'd had a baby, he or she would have been illegitimate. Her mind ran past all the potential problems this dredged up. She and Devlin had filed income taxes jointly. They'd bought this place together. She glanced around. How would this affect their joint property—

specifically this house? Would they have to sell it?

Did she *want* to be part of a lawsuit? Did she want this fiasco to become public? She needed to talk to a lawyer, someone she could trust to advise her and keep this a secret. Finally, Brynna glanced at her watch and sorted through her thoughts for a plan. She would call an attorney first thing in the morning.

With another crisis to deal with, she'd lost what little appetite she'd had. Tossing her dinner into the wastebasket, she went upstairs to shower.

Brynna wasn't able to set up an appointment with a lawyer immediately and had to wait a day for a legal consultation in Billings. Dev had an attorney who handled all of his legal matters, but she couldn't go to Dev's lawyer without his permission, and she wasn't ready to divulge this latest development until she knew where she stood—until she had a strategy.

She'd taken the evening off from the clinic for dinner at her sister's, so, after seeing the lawyer she drove back to Rumor and pulled into Frank and Melanie's driveway. No sooner

had she parked her car and gotten out than Dev's pickup turned in behind her. He got out and studied her from beneath the brim of his Stetson.

His eyes were shaded, so she couldn't see his expression. "Have we been set up?"

His voice conveyed his displeasure. Brynna's head spun for a few seconds before she collected her thoughts. "Apparently. Were you invited to dinner?"

He nodded. "I'll go. You stay and see your family." Dev started to get back into his truck.

"Wait," she said quickly.

He stopped and looked at her skeptically. "What?"

She approached the driver's side of his truck. He stood half-in, half-out, one booted foot on the running board. "You enjoy seeing the boys as much as I do. Stay."

Adjusting the brim of his hat, he avoided looking at her. "I don't know. That's probably not a good idea."

"Then I'll leave," she said, "so you can see them. Just back up and let me out." She headed for her car.

"You're here!" Melanie came around the

side of the house and greeted them. "The boys have been waiting for you."

"Melanie, what were you trying to do?" Brynna asked, her voice low, but not caring whether or not Dev overheard.

Her sister pulled an innocent expression and looped her arm through Brynna's. "Arrange a nice family dinner is all. Come on, Dev, shut your door and join us out back. Frank is waiting for your direction on the steaks."

Reluctantly, Dev tossed his hat on the seat, shut the truck door, and joined them.

They were greeted in the backyard by John and Chandler, who gave Brynna hugs and pounced on Dev, demanding his attention. He swung them around and they chortled with excitement. Frank placed the steaks on the grill, and Melanie brought frosty glasses of iced tea.

Brynna accepted one and took a sip. She snuck a sidelong glance at her—at Dev. Dev wasn't her husband, but for now she was the only one besides a few lawyers who knew that fact.

According to the attorney she'd spoken with, their joint property wouldn't be a problem. The house could be sold and the money divided.

The thought of selling their house disturbed her. It was the only thing linking them.

Kurt showed up a few minutes later and joined them on the patio. He gave Brynna a hug. "Mel told me what happened," he said softly. "Sorry to hear it, Brynn."

She nodded, silently accepting his condolences.

"You feeling okay?" he asked.

"Yes, I'm fine."

"You'll have another baby," he assured her. Brynna knew people said that as the only way they knew to comfort someone who'd had a miscarriage, but it wasn't as though another child could replace one you'd lost.

Her future was so precarious, she had no idea whether or not she'd ever have another chance to have a baby. Brynna glanced toward Dev, hoping he hadn't overheard Kurt's words.

She wasn't sure if he had or not, because he was paying rapt attention to a miniature airplane that John had brought out to him for help in getting the wheels back on. "You do this stuff on real planes all the time, don't ya, Uncle Dev?"

The two were absorbed in the plane, snip-

pets of their conversation drifting to Brynna, and Dev didn't look her way.

"Can't believe that fire's been burning this long," Frank commented some time later, and nodded toward where soot could be seen in the distance. Every so often the wind carried the scent of smoke this far. "This makes about twelve days, I think."

"The volunteer fire squad has set up camp to the south," Dev told them. "Ash McDonough left with them."

"I heard they've started evacuating," Melanie added.

"The situation does seem to be getting worse instead of better," Brynna said. Reports coming in were not good.

Frank carried the cooked meat indoors and they ate, Frank's police scanner squawking in the background as usual.

"You could shut that thing off while we eat," Melanie said, so sweetly that Brynna knew it was a point of contention between them.

"Don't want to miss anything," her husband replied. "They have an emergency situation with the evacuation right now. They've sent choppers to a resort area."

"You can hear all that?" Brynna asked.

"I hear our fire and police communication," he replied. "Right now they're calling for medivacs from other counties."

"Aunt Brynn, Mom made that cloesaw," Chandler told her. "Do you like it?"

"I happen to love cloesaw," she replied, mimicking his mispronunciation with a grin. "And your mom's is the best."

They had finished eating when Brynna's pager throbbed at her hip. With a mental groan, she identified the number as the hospital's and used the kitchen phone to get ahold of them.

"We have a situation," one of the attendants said when she got through. "Female, thirty-two weeks pregnant. Contractions ten minutes apart."

"Where is she?" Brynna asked, hoping the patient was already at the hospital, so she could order meds.

"That's the problem. She and her boyfriend and another couple are camping."

Brynna had a bad feeling about the information she guessed was coming next. "Where?"

"Big Bear Lake." The physician named the remote location near Custer National Park.

"The access roads on this side are in the blaze. They can drive out the other direction, but it would take a day or two to reach help. Same with getting anyone in to them on the ground."

Not a good situation for mother or baby. "Good Lord, didn't her OB advise her to stay near home?"

"All the local choppers are in use," the doctor told her, without answering her rhetorical question. "Plane can't land up there. You can talk to the boyfriend. Advise him."

"She needs medical treatment immediately," Brynna said, mildly alarmed.

"We have an alert out for the first available helicopter and more help is on the way," he said. "That's all I can tell you. Go to the sheriff's, they can patch you through."

Brynna hung up. "I have to go."

"What's the problem?" Dev asked, and after she'd explained, said, "I'll come with you."

In a matter of minutes they reached the sheriff's department, which was just down the road from Frank and Melanie's on Logan Street. Brynna spoke to the anxious young boyfriend and instructed him on how to calm and assist his girlfriend.

Behind her, Dev spoke with the deputies.

"Can't get anything but a chopper in there," Tommy Royce, the younger of the two said, "and we're waiting out another emergency."

Isaiah Beauford had worked for Rumor's sheriff department for as long as anyone could remember and knew all the residents, past and present. "Could land a seaplane on the lake, but only body around here has one is Pete Spencer, and he's off fighting the fire."

"I can fly it," Dev said.

The deputies looked hopeful, and Brynna turned to listen.

"You certified?" Tommy asked.

"Single-engine sea rating only takes ten hours of flight training," Dev replied with a nod.

"Hang on," Brynna said to the young man on the other end of the phone line. "Dev, can you get me there?"

"If they can get Spencer's permission to take his plane, I can get you there."

Tommy lunged for a phone.

"If we can get meds to her, I can slow her labor enough to get her to the hospital," Brynna said. "Can we fly her back to White-horn?"

"Don't see why not."

"Tell your girlfriend to hold on," Brynna told the young man on the phone. "We're coming to get her."

Chapter Twelve

Pete Spencer's plane was on floats on Lake Monet, where Pete owned a small home. His wife provided Dev with all the information and papers he needed, and one of the nurses met them with the meds and equipment Brynna had requested. Within half an hour Dev had loaded Brynna's supplies and they were in the air.

She adjusted a headset over her ears, so they could communicate above the engine and wind noise. "How long?" she asked, already peering ahead to the hazy mountain range.

"Twenty minutes at the most," he said. "As

long as visibility is fair and we find the water, we're good."

Now that they were alone and she had time to think, the information she'd been given about the lawsuit nagged at her. Somehow it was even too embarrassing for Dev to know what had been done to them. He would have to know, of course, but she was afraid of his reaction. She didn't want to see relief on his face. If she handled the details ahead of time, there would be little discussion. At least that's what she'd been hoping.

The break would be clean and efficient. There was nothing she could do to make it painless.

As they neared the spreading blaze, the sight from the air brought the enormity and danger into perspective. Vehicles of all kinds lined the crooked tree-lined roads leading to the site of the fire. Deer and turkey, as well as small animals, fled the blaze in amazing numbers. The thick smoke obscured visibility at ground zero, so Dev flew them around the edges.

"Oh, my…" Brynna breathed.

The stench of soot and ash that reached them made the hair on Brynna's neck stand on end. Her heart dropped at the devastation

as plumes of smoke rose from acres of charred timber that had once been lush green forest.

"No wonder nothing can get in or out of these roads," she said.

His expression grim, Dev observed the control panel. "Keep an eye out for Big Bear Lake," he said.

Brynna scanned the scenery below where roads and trees looked like miniature toys. Thank goodness Dev did this kind of thing all the time, because she couldn't tell one landmark from another. She had complete faith that he would get them there, land and get them out safely.

"There!" she said and pointed to a body of water up ahead and to the right.

"Got it," he replied and dropped altitude. Brynna's stomach dipped with the motion. He glanced over at her. "You okay?"

"Fine," she assured him.

With skillful control, Dev landed the seaplane smoothly on the surface, and they glided toward the east shoreline, where the landmarks they'd been given indicated they'd found the right spot.

"There they are," Dev said, spotting two

figures in shorts and T-shirts waving from the bank.

"She's over here!" The young man and woman led Brynna toward a tent.

Phoebe Conner was a teenager. She had dark blond hair with unnatural red steaks, front sections worn in braids that fell alongside her pale face. Moving in closer, Brynna noticed the silver ring through her nostril.

"God, I'm glad you're here," Phoebe said with a northern accent, tearstains marring her cheeks. "Am I going to die? Is my baby going to die?" She gripped Brynna's hand with fingers bearing half a dozen silver rings.

"You're going to be okay," Brynna assured her. "How far apart are the contractions now?"

"Still ten minutes," the lanky boyfriend said from beside her. "I'm Robbie. I got her feet up like you said. And I made her drink water."

"Good job, Robbie. I'm going to take your vitals, Phoebe, then start this IV. I'll do an exam, and we'll get you out of here and to the hospital as soon as we can. This is my—this is Dcvlin Holmes, and he's going to fly you out of here."

Brynna took the girl's blood pressure, listened to her heart and looked at her pupils.

Dev and Robbie stepped out of the tent. Brynna checked Phoebe's cervix, relieved to find it hadn't softened. She checked the baby's position and listened to his heartbeat. Afterward, she called to the men to reenter as she cleaned an area on Phoebe's arm, found a vein and started an IV.

"Robbie's coming with me, right?" Phoebe asked.

"I'm afraid the plane won't take the extra weight," Dev said. Apparently, he'd known that all along, but hadn't mentioned it to Brynna.

Phoebe started to cry.

Robbie took her hand. "I'll get there as soon as I can," he promised her. "These people will take good care of you."

"But what if the baby comes?" she wailed.

"We're going to do everything we can to prevent that," Brynna told her, fastening her arm to a splint so the IV wouldn't get jostled. "When was your last checkup?"

"Two weeks ago."

"Did your doctor estimate the baby's weight then?"

Phoebe shook her head.

"I'm guessing he's a good four pounds, so even if we can't stop your labor, your baby has an excellent chance. We want him bigger of course, and his lungs more developed before he's born, but we can take care of that if need be. I'm starting you on steroids now, as a precaution."

"What will that do?"

"They will help develop his lungs just in case he comes early."

"Okay," Phoebe said, trusting Brynna with her child's welfare. "Okay." She had calmed down. "Thank you, Dr. Holmes."

"Yeah, thanks for coming out here to help us," Robbie said awkwardly.

"Thank Dev, he's the one who got me here—and the one who will get Phoebe to the hospital."

"Get on the road now and head north," Dev told Robbie and the other two young people without giving them time to say their thanks. "Stay in plain sight. That fire could change direction at any minute. If it does, someone will come for you, because they're aware of your location."

"We'll be fine," Robbie replied.

"Ready?" Dev asked Brynna. He had car-

ried in a stretcher, and looked to her for instruction.

She held up the IV bag and tubing. "You two move her onto the stretcher and I'll carry this and keep her arm stable. Let's go."

They moved quickly and carefully, settling Phoebe into the plane in the cramped space behind the two seats. Robbie kissed her lips, kissed her protruding belly through her shirt, then backed out while she waved tearfully. Brynna wedged in to sit beside her, and Dev started the engine.

The plane skimmed the surface of the lake and in minutes they were in the air and headed for Whitehorn.

"Oh, my gosh," Phoebe said as the plane ascended. She placed her hand on her belly.

Brynna immediately placed her fingers on the girl's abdomen, checking for a contraction, but her uterus was not hard. "What is it?"

"Nothing, I'm okay. I'm just not used to flying."

Dev handed headsets to both women. "Where are you from, Phoebe?" he asked over the engine noise. Brynna silently thanked him for finding a distraction.

"North Dakota," she said adjusting hers.

That explained the accent. "We were driving through and we didn't realize we were so close to the fire. I started feeling sick yesterday, so we stopped for the night."

"Were you drinking enough water?" Brynna asked. "I think you're dehydrated. That might have brought on the contractions."

"Maybe not enough."

"Good thing you had a cell phone," Brynna told her.

"I always crack on Robbie for bringing that thing everywhere. This time I'm glad he had it." Phoebe's gaze took in the sky outside the windows of the plane. "Are we near the fire?"

Brynna nodded and rose to her knees to peer out of the plane. Dev glanced back just then, and they exchanged a look.

Brynna sat down.

"Is he your husband?" Phoebe asked. "You both have the same name."

Brynna's heartbeat stumbled to a near stop, then caught its natural rhythm. She nodded with what she hoped was a smile. *Her name wasn't really Holmes. She was still Brynna Shaw.*

"Robbie and I weren't ready to get married," the girl said. "I'm just nineteen and he's twenty.

He's going to college and has a long time left. But we've been talking about it lately. I guess it would be good for our kid to have a mom and a dad with the same name, huh?"

"A decision like that needs to be made for the right reasons," Brynna told her, definitely not feeling like giving advice and wary of her words because Dev was listening in the earphones.

"How long have you guys been married?" Phoebe asked.

"Eight and a half months," Brynna lied with an ache in her chest. *They weren't really married.*

"So you're newlyweds!" Phoebe replied. "My mom says the first seven years are the worst, and if you can get through those, you have it made. I don't think she was kidding."

"Probably not," Brynna replied.

"She was really mad at me for getting, you know, knocked up. I was taking the Pill, but she said I was careless. My doctor said I probably got pregnant when I had to take some antibiotics. Think that's possible?"

Brynna nodded. "A lot of things can make birth control ineffective. That's one of them."

"I wish you'd tell my mom that."

"Wait till she sees this baby in another month," Dev assured her. "She'll come around." His words caught Brynna off guard, but meant a lot to the girl whose eyes misted.

"Think so?" Phoebe asked.

"I know it," Brynna said confidently.

"Lake Monet ahead," Dev announced. "Ambulance standing by."

Brynna smiled at Phoebe and held her hand tightly. The plane dipped.

"I think I'm going to throw up," Phoebe said, her face starkly pale.

Brynna zipped open her medical bag and yanked out a plastic bag. "Take slow deep breaths. We're almost there."

Within minutes, Dev had the plane on the water, and they were met by the paramedics. Dev jumped out and helped them with the stretcher, then assisted Brynna out of the water, carrying her bag for her.

Phoebe's nausea had passed by the time Brynna climbed into the ambulance where the medical workers hovered over their patient. Dev tucked her bag in beside Brynna. The doors closed. The siren wailed.

Glancing through the back windows, Brynna glimpsed Dev standing on the road, boots

dark, jeans wet to his knees. He stood watching the ambulance depart, his sandy hair shining under the setting Montana sun. This moment, like all others with Dev, seemed incomplete. There was so much left unfinished between them.

How it would all turn out, she had no idea... and was afraid to predict.

Phoebe Connor's contractions stopped that evening. Her baby's vitals were excellent, and Brynna assured her that after another day or two without contractions, they would talk about letting her travel home. Just as they were finishing their conversation, the door to the room burst open and a disheveled Robbie hurried toward the bed.

"Robbie!" Phoebe flung her arms around his neck and he hugged her back. They kissed so passionately, that Brynna looked the other way and made a few notes on the chart. "How did you get here?" Phoebe asked. "It should have taken you over two days!"

"We were driving and Justin noticed a small plane that kept flying above us. We stopped the car to look. It was Dr. Holmes's husband. He showed us where he was going

to land, and we met the plane, then he flew me here."

Holding Robbie's hand, Phoebe looked at Brynna with eyes full of tears. "Did you send him to get Robbie?"

Brynna shook her head. "I had no idea."

No idea whatsoever. What an incredibly kind thing to do. Brynna wished Dev could have seen Phoebe's eyes when Robbie entered that room. He had made two people very happy. And quite likely saved them the anguish of a premature baby.

"Thank him for us, Doc," Phoebe said.

"I will."

"He's a great guy," Robbie added.

She wished them a good-night and left them alone. At the nurses' station, she left instructions, then checked on another patient before leaving the hospital.

It had been a long, exhausting day, and she couldn't wait to get home and shower. She didn't know if she imagined the smell of smoke on her hair and clothes or if it was really there.

Home.

The word didn't hold the same connotation it had a month ago, when she had been bliss-

fully ignorant of what was to come. Back then she'd still been deceiving herself that loving Dev enough could make their relationship work.

Granted, she was to blame for much of what had gone wrong. She'd reacted badly, had been hurt and unforgiving. On top of it she'd been indecisive, too, and he was rightfully angry with her over that.

They'd shared something pretty important tonight. And Dev had gone out of his way to see that the two young people were together. Where was he now? Driving along the dark highway toward Rumor, Brynna pulled out her cell phone. She held it for several minutes, garnering courage before dialing Dev's number.

He answered on the second ring. "Yes?"

He'd seen the caller ID.

"That was a really nice thing you did, bringing Robbie to Whitehorn."

"Was she glad to see him?"

"I wish you could have seen her face."

"Kodak moment, huh?"

"Definitely."

Silence.

"Dev, I..." She thought for a few seconds, not sure of what she'd been about to say. "I

couldn't have helped that girl without you, you know. You probably prevented that baby from coming too early."

"You did that. I just flew the plane."

"Well, we did it together then."

Silence.

He was still angry with her. She *hated* the way it felt. It was unlike him to be unresponsive. But then every time he'd made an overture, she'd inflicted injury. He'd become as self-protective as she was, and she couldn't fault him for it. And there was more to come. Much more.

"We need to talk," she told him.

"Okay."

"Not like this. Not over the phone."

"I'm not coming to the house."

That hurt. But he was perfectly justified. "Why don't we meet tomorrow. After work."

"Where?"

They couldn't have this talk in a public place, so the Rooftop Café and the Calico Diner were out. "Why don't I pick up dinner and meet you out at Lake Monet?"

He didn't reply right away. "All right. I'll park by the picnic area. What time? Aren't you working at the clinic?"

"About seven. I'll leave early."

"See you then." He broke the connection.

Again Brynna wondered where he was. In his room at Colby's ranch house? At Joe's Bar? She hadn't heard anything in the background, like music or laughter or pool balls clacking.

Deliberately, she drove down Main and looked for the Lariat along the curb or in the parking lot, but didn't see it. A truck like that was hard to miss.

Driving to Logan Street, she turned north, then onto her street—Lost Lane. All the time she'd lived in her apartment, she'd never thought anything of coming home to an empty place. After years of living with her siblings and then in crowded dorms, she'd been grateful for the solitude. Now, however...after having lived here with Dev...after sharing chores and meals...and a bed...

The house seemed too quiet. Too empty. Far too lonely.

She was a big girl. An independent career woman. She would get through this. Get over him. Get on with her life.

She unlocked the door and stepped into the empty house.

Somehow.

Chapter Thirteen

Dev parked the Lariat in the deserted parking area and got out to walk along the edge of the lake. Supposedly its name had come from a long-ago romantic Rumor citizen who had likened the flashes of color on the water's surface to a Monet painting. The water had been low this year, and the haze in the sky dimmed the usually sparkling reflections. He walked through the tall dry grass, frogs leaping into the water for safety.

Brynna's car pulled up beside his truck, so he turned and headed toward it. Uneasiness overpowered his usual pleasure at seeing

her. He didn't know what to make of anything anymore, didn't know what to do except leave well enough alone. This time she had initiated their encounter, good enough reason for anxiety.

Brynna carried a red plaid blanket and two paper bags toward the grassy area surrounding the lake. She had changed after work and wore slim-fitting jeans and a sleeveless white sweater, her lovely feminine appearance affecting him as it always did. Keeping things in perspective, Dev joined her and spread out the blanket.

"I got dinner at the deli in MonMart," she said, sitting down and kicking off her sandals. "It's the chicken you like."

He noticed the smooth skin of her slender shoulder and flexed his hand a couple of times to keep from reaching out and stroking her flesh. "Sounds good." Deliberately ignoring her sexy bare feet, he sat and helped her open plastic containers. "How's Phoebe?"

"She's doing really well. We got fluids in her and she hasn't had a contraction since yesterday."

"So she'll get to go home?"

"I'm making her wait another day, just to be sure."

"Tell her I'll fly them home. That way she won't have to drive to the airport or wait in terminals."

"That's very kind of you, Dev."

He shrugged. It was just something he knew how to do, and he wanted to be helpful. He'd been thinking he would join the workers fighting the blaze now heading toward Custer. He didn't have training for firefighting, but he could bring in food and supplies or fly out the injured. He could handle air reconnaissance. He'd hung back from volunteering, believing Brynna needed him, but it had grown glaringly obvious that she didn't.

He might as well be somewhere he was welcome.

They ate, their conversation stilted. Finally, Brynna gathered the empty containers. "There's something we need to talk about."

"I've been waiting."

She glanced toward the lake, then down at her hands, as if she didn't want to speak about whatever it was she had on her mind. Dev was really nervous now. If she brought up a divorce, he didn't know what he would say.

What did he have to offer that would change her mind?

Abruptly, she rose on her knees, dug into her jeans pocket and took out a piece of paper, which she unfolded and offered him.

Dev accepted the paper, straightened out the creases and glanced from her face to the printing.

"Just read it," she said.

The letter, from a law firm in Las Vegas, was addressed to both of them. Dev read the contents, at first not comprehending, and then realization dawned. The import fell on him like a load of rocks, squeezing the breath from his chest, pressing the life from his heart.

He looked up and met her probing brown eyes, darker and more serious than ever.

"Is this legitimate?"

She nodded. "I had an attorney investigate. It's all correct."

An attorney? She'd had time to talk to a lawyer? "When did you get this?"

"It came on Monday."

Anger pushed every other emotion to the side. All the fear, all the uncertainty, the sense of betrayal and personal violation slid aside for the all-consuming fury that welled up and

spilled over. "You knew this four days ago and you just now saw fit to tell me."

It was a statement, his voice controlled and hard.

"Yes," she said. "I made sure that the accusation was correct and that the lawsuit was legit."

"That it's true we're not legally married."

She nodded and looked away. "I found out where we stood on the house."

Dev's thoughts tumbled into semicoherence. "The house? What are you talking about, the house?"

"I wanted to know how this affected our joint property," she began.

Dev jumped up from the blanket and paced, several feet away, then stormed back and glared down at her. "What the hell does the damned house have to do with anything?"

Brynna's startled expression showed her surprise at his shout, but she remained calm. "We bought it together, as man and wife, I wanted to know what that would mean, legally."

It meant they'd been duped, damn it! His whole world was crashing down around him and she was thinking about joint property.

Didn't she give a damn about what this meant to them as a *couple?* "What difference does it make?"

She looked at him then, her brown eyes wide and round, but said nothing.

"You learn that we were cheated out of a legal marriage, that a man claimed to marry us, but scammed us instead." His insides felt like something was stretched so tight it was going to snap. "We lived together and made a life—we made a *baby,* thinking we were husband and wife when legally we weren't. You find out all that and your first concern is what you'll get out of *the house?*"

"No, not what I'd get out of it..."

"You can have the damned house, Brynna," he said, throwing the letter down in her lap. "You're the one who insisted you share the cost. I could have bought the place a dozen times over, but splitting it was important to you." His words were bitter and cruel, but he didn't care. "So keep the damned house. The hell with everything." So angry he could hardly see clearly, Dev struggled to regain his composure.

The breeze fluttered the letter, and Brynna

caught it with trembling fingers and folded it neatly against her denim-clad knee.

"You know what?" he said, biting out the declaration fast and hard. "The hell with this, too. This is what you want." With a rough twist, he jerked off his wedding ring. She had a way out, a back door to escape their marriage, and sure as hell, she'd champed at the bit to take advantage of it.

With a burst of adrenaline, Dev hurled the ring out over the water, where the sun caught it for a gleaming timeless moment before the band arced downward and plunked into the lake with a small unsatisfying splash.

"There. Done. You have what you want— you're free of me."

He looked at her then, and the expression in her dark eyes was one he'd never forget. Shock. Fear. Disappointment. Pain? He was torn between kneeling beside her and pleading for her understanding and acceptance and shaking her until her teeth rattled.

If he looked at her any longer, if he stayed, if he said another word, he'd break into a million pieces, so he stalked toward his truck and found himself backing it out and gunning the

engine to get away from there. Away from her. From himself.

It wasn't working. He'd never get far enough away to ease this horrible gut-wrenching sense of betrayal. But he could try.

Chapter Fourteen

Brynna listened to the sound of the Lariat's throbbing engine disappear. Somewhere a bird chirped, the sound echoing across the water, a surreal sort of taunt that reminded her again that life went on. No matter what. People ate and had babies and went to work and got sick and shopped; daily life revolved endlessly, no matter what the crisis.

Gazing across the surface of the lake, she imagined Dev's ring on the murky bottom somewhere, saw again the spinning gold band as it arced over the water almost in slow motion. Her heart had stopped while the ring was

suspended in air, and she wasn't sure if it had started beating again since. She was breathing, so it must have. But she didn't feel alive. *I'm dead inside.*

A ringing brought her out of her daze, and she realized it was her phone, which she'd left in the car. Her heart skipped a beat at the crazy thought that it might be Dev. Gathering the trash and the blanket, she answered the call.

"Brynn, are you working?" It was Melanie.

Her insides were still quaking. "No."

"I'm in a jam, can you come over and stay with the boys for a while?"

An evening with John and Chandler would keep her mind occupied—at least for a while. "Sure, I'll be there in a few minutes."

She sat in the car, absently watching a hawk circle above the lake. It swooped down toward the bank, and she closed her lids over her burning eyes. Dev had been angrier that she'd withheld the information about their marriage for a few days than he had been about the actual fact. *What have I done?*

Her obsessive need to control everything had added to their problem, and she knew it. Closing both hands into fists, she tapped them against the steering wheel and pursed her lips

in helpless frustration. Slowly, she opened her left hand and stared at the diamond-encrusted wedding ring set on her third finger.

Three karats, all together worth more than her car or anything else she'd ever owned in her life. He'd pulled the rings from his pocket the day they were—the day they had *believed* they were married in Las Vegas. She'd told Dev the jewels were excessive. "So is my love," he'd said with a guileless grin, one that turned up one side of his mouth and started heat pounding in her veins.

Oh, he'd loved her in the ways he knew how, with his body and his money. But had his heart ever been involved? He believed so, she was sure. *Did you ever love me, Dev? Truly love me?*

Reckless, that's what she'd been. Reckless with her own heart. And now what did she have to show for it? The diamonds glittered with a life of their own in the sunlight. How easy it had been for him to twist off that wedding band and toss it into the lake. Another tether cut. Was there anything still holding him to her?

Bringing herself out of her reverie, Brynna started the car and headed for Melanie's. If

she entertained any more thoughts like this, she'd be wallowing in self-pity for the rest of the night as well as all the days to come. Dev wasn't exactly something she could shake off and forget. No matter how much she tried or how many little boys she sat for.

She arrived at the house in time for Melanie to sweep out in a rose-scented hurry. She kissed her sons and waved at Brynna, eager to be on her way.

Brynna turned to the boys and asked if they'd eaten dinner.

"Yup," Chandler said, and indeed, Brynna discovered a sink full of dishes and dirty pans on the stove. She ran water and submerged the pans to soak.

Her nephews called for her to come see what they were doing. The two were nothing if not inventive. They had created a fort out of sheets from the linen closet and cardboard boxes they'd found in the garage. "Help us turn the fort into a castle, Aunt Brynn!" Chandler begged.

"I was going to do up those dishes for your mom," she said.

The boys met her reply with crestfallen expressions.

"Can Unca Dev come over?" Chandler asked innocently. "He will play with us." He ran over to the portable phone where it lay on a table and picked it up. "What are his numbers?"

"I'm afraid Uncle Dev can't be here tonight," she replied, gently taking the phone and replacing it.

"Come on," John said, taking his little brother's hand and pulling him away. "We'll do the castle ourselves."

She watched them walk away, hand in hand, and the image of Dev playing with them rose in her mind. Dev always stopped whatever he was doing and joined the children—or, more often, he had actually instigated the play. *What's wrong with me?*

It sometimes irritated her that others seemed to be having all the fun while she took care of the real-life details. Things got done because she did them. What would happen if she let the details go this one time?

"Never mind the dishes," she said, changing her mind aloud in a hasty decision. Melanie could do her own dishes whenever she got home.

Brynna located duct tape and markers and

joined John and Chandler in the family room. Soon they had converted the fort to a castle. She was the fair maiden and John and Chandler became the handsome knights who had to fight the imaginary dragon with nylon spatulas to rescue her. They played so hard, she couldn't help laughing at their fierce determination to end the poor sofa's life.

This was what she had wanted for herself, kids...a family. Would Melanie's family have to meet those needs forever? The growing fear that she would never have the desires of her heart sobered her and made her think of Dev all over again.

He was in her heart, in her head, in her blood. "Let's go run your bath, fellas," she said.

By the time Frank came home, she had the boys bathed and tucked in their beds, sound asleep. She had deliberately walked past the dishes to prepare herself a cup of tea before watching the news. Frank let himself in and joined her in the disheveled family room. He tossed aside a spatula and a throw pillow to sit. "What happened in here?"

"Just your run-of-the-mill dragon slaying," she replied.

"Thanks for coming over. Melanie could have stayed when she knew I had to work late, but she insisted it was her night to take in a craft fair in Whitehorn, and she wasn't going to miss it."

"Have you two come to any kind of agreement over her working part-time?" Brynna asked.

"Are you going to nag me, too?" he answered back. "The boys need her here."

Even after that stock comment, Brynna felt comfortable talking candidly to her brother-in-law. They'd had serious discussions in the past and always respected each other's opinions. "They need a mother who is fulfilled and not resentful of the time required to raise a family. You have time away from the house while you're at work, but she doesn't. She's here 24/7."

He pulled a face. "You're starting to sound like her."

"She could work hours opposite yours, or place the kids in day care a couple of days a week. Children enjoy a change of scenery and other kids to play with."

Frank gave her a thoughtful look. "I just don't want the boys to feel neglected."

"I understand completely, really I do. Trust me, I would recognize neglect. But Melanie isn't like our parents. She has devoted all her time and energy to this family. Trust her to know what's good for her and for the boys and your marriage. You might have to experiment with an arrangement, but you can work out something." Brynna stood and carried her cup to the kitchen, then returned for her purse and keys.

Frank walked her out to her car.

She stood beside the fender.

"What's happening with you and Dev?" he asked.

She studied the sky. "He's not living at the house."

"What happened? I don't mean to pry, but I know about the miscarriage, and then about him missing Tuck's birthday. There must be something in between, and if you've shared secrets with Mel, she hasn't told me."

"It's complicated," she said. "He never wanted the baby. The pregnancy wasn't planned, so it was a surprise to both of us, but he was relieved over what eventually happened."

"I have trouble believing that," Frank said.

She told him what Dev had said that afternoon at the hospital and about his apology afterward.

"This situation isn't all about him saying those things, is it? I mean guys are pretty clueless when it comes to stuff like that, and I can sure see him grasping at anything just to make you feel better. He said he didn't mean it like that and yet you asked him to leave. That's just a misunderstanding over words, not a reason for a breakup."

Frank liked Dev—everyone liked Dev, what was not to like? But his simple observation and defense echoed the truth.

"There is more," she admitted. "I was never sure about us. I knew from the very start that I was jumping headfirst into something I wasn't prepared for. There was no planning or foresight with us, we just barreled straight ahead without looking. I barely knew him."

"And what, you're sorry? You don't really love him? He doesn't make you happy? What?"

She shook her head; no explanation would sound logical.

"You're just scared, plain and simple. Everybody's scared of getting married, even if

they've known each other a long time. You can't predict a happy ending by *planning* it," he scoffed.

She didn't have a ready reply.

"You beat it all, sis. You're the smartest woman I know and yet you're the dumbest, all rolled into one."

She stared at her brother-in-law in the glow from the streetlight. She was more afraid of taking chances than she was of being alone. At least being alone was familiar. An uncertain future with a man who might or might not commit to a family with her was a fear she couldn't accept. "I guess I am," she said at last.

He gave her an understanding brotherly hug, and she pulled away before she cried. Frank thanked her again and she wished him a goodnight.

No stars were visible in the soot-dark sky, and Brynna was glad the drive home was a short one. It had been easier to think about and discuss Frank and Melanie's problems than to think about her own, and Frank had dragged it all out for her to examine again.

She hadn't told her brother-in-law the rest of it: about the letter and how she hadn't told Dev until today. Today had been a nightmare,

one she would probably relive every time she closed her eyes and tried to sleep.

She hadn't moved past showing Dev the letter. That had been as far as the discussion had gone before he'd blown up and left. Nothing had been discussed or planned about what they would do. As if there was a solution or a plan that would make a difference. Every time she thought about Dev working his wedding ring off and throwing it into the lake, she felt sick. Sick at heart, sick with herself and her controlling behavior, which had caused the problem.

A day later, Brynna was drying her hair in the morning when the phone rang. She didn't recognize the caller ID. "Hello?"

"Brynna?"

"Yes?"

"Dear, this is Estelle," Dev's mother identified herself. "I'm on my way back to Seattle from the east coast, and I'll be stopping by to visit this evening. Is Devlin there now? I thought he could meet me in Denver and escort me in one of his planes."

"Uh, no." Caught off guard by the unexpected call, she fumbled for something to say—something to deter the woman. "He's

not. I heard—well, actually he's helping with the fire."

"I saw the fire on the news," Estelle exclaimed. "It's dreadfully close to your little town, isn't it?"

"It's headed south now, but it's not contained."

"Is Devlin doing something dangerous?"

"Any rescue work has an element of risk," Brynna replied.

"Well, at least he's settled down and gotten married," she said. Brynna hadn't been Estelle's ideal choice, since she wasn't a wealthy socialite, but the woman had been accepting of the union.

Brynna caught her breath. She and Dev weren't really married. Who was going to tell Dev's mother—his family? Brynna didn't think he spoke to her very often, and it was obvious he hadn't talked to her in the last couple of days. "I'll have him phone you, Estelle," she said. "Where can he reach you?"

The woman rattled off a number and Brynna jotted it down on the mirror with an eyebrow pencil.

"I'll see you this evening," she said. "Don't plan anything fancy."

"All right." Brynna pressed the off button and stared at her reflection with an expression of near-panic. Estelle had only visited them one other time, and that had been after they'd just moved into this house. Their things had still been packed in boxes, but after assuring Brynna that both of Rumor's motels were out of the question, Dev had made up a guest room for his mother.

Nerves jangling, she dialed Dev's cell phone.

Chapter Fifteen

"Yes?"

"Dev, where are you?"

"I'm in Big Timber loading donated supplies for the teams." His voice was so achingly familiar, the sound gave her pause. "Is something wrong?" he asked.

"Yes—no—not terribly wrong. It's just that your mother called to say she'll be visiting us this evening. She wants you to meet her in Denver to bring her here."

Dev mumbled something that sounded like a mild curse. "Great timing," he added, "the woman always had great timing."

"I didn't know what to say."

"I don't either."

"Do you want to tell her?" she asked, referring to the truth about their situation.

"No, I don't want to tell her. I don't want to tell anyone." He said the second part so softly she could barely hear him. "I don't want to admit it."

She knew how he was feeling—partially anyway. "We can get through an evening with her, right? Can you get away?"

"Everybody has to stop to eat and sleep," he replied.

"I'll think of something for dinner, and you let me know what time you'll be bringing her."

"Okay. Thanks, Brynna."

"Don't thank me. I don't deserve thanks."

He didn't say anything for a moment. "So we'll just eat a meal and pretend like things are normal?"

"I guess so. Do you have a better idea?"

"No."

"All right." She wanted to tell him to be careful, that she missed him and had thought of nothing but the things they'd said over the last two weeks. That yesterday had been the worst day of her life. That him throwing his

wedding ring away had shattered her last pretense. But she couldn't. "Later, then."

At the hospital, she queried the nurses on what would be best to serve for dinner and took suggestions. She wouldn't have much time to cook by the time she stopped for groceries and got home. Emma thought the best solution would be to pick up something at MonMart and Rae Ann suggested she order a pie from the Calico Diner. Sounded simple enough to her.

Lord, Estelle Holmes had eaten in the best restaurants in Europe and Brynna was planning to serve her something from the *deli?* She fretted over the meal all day, finally deciding on a simple fare of chicken and vegetables. She could buy the chicken and dessert already prepared and cook the vegetables quickly.

At a little after five, Brynna walked out of the Calico Diner with a boxed strawberry-rhubarb pie, realizing as she reached her car and placed the package on the back seat that she had bought Dev's favorite. She stared at the box. Would he read meaning into her purchase? Was there any meaning, except that she was in the habit of thinking of them as a couple?.

At six-thirty, the front door opened and Dev called out, "We're here!"

Brynna smoothed her palms over her slacks and checked her hair in her reflection on the microwave door before going out to greet her mother-in—before going out to greet Dev's mother. "Estelle," she said warmly, "how nice to see you."

Estelle aimed a peck toward the cheek, but it missed. Her expensive perfume was a subtle essence all her own. She was a tall woman, slender with angular shoulders and hips she disguised in cashmere designer suits. Her hair was a beautiful silver white, and she always wore it in an elegantly loose roll with seemingly careless wisps that framed her cheeks. Today she wore yellow diamond earrings with a camel-colored suit. "It's lovely to see you, too, my dear."

"Was your flight okay?"

"Devlin's a good pilot," she said. "His planes aren't first-class accommodations, but they're better than driving. He even had roses for me." She turned to her son. "Where are those? I'll want them in water in my room."

Dev exchanged a look with Brynna. *Her room?* She planned to stay? If she stayed, how

would they keep up the ruse that Dev was still living here?

"I'll bring them in when I get your other bags," he replied and placed her butter-colored leather carry-on on the floor.

"I'm sure you'd like to freshen up before dinner," Brynna said. "I've laid out towels, and you can use the guest room to change."

"Thank you. Devlin will bring my things." Estelle picked up her carry-on and headed up the stairs. "You've done some decorating," she commented, glancing around.

"Some." Once Estelle was out of earshot, Brynna turned to Dev. "She's staying?"

He nodded. "At least one night. Apparently painters aren't finished with her rooms at home, and she's delaying her arrival. I'm sorry, Brynna. My only options were to tell her the truth and fly her on to Seattle or bring her here."

"You had to bring her, of course. We can't tell her." Brynna raised her clasped hands to her lips in thought. She met Dev's green eyes and saw his gaze move to the wedding ring she wore.

She forced herself to not look at his left hand at his side, not to seek out the empty ring fin-

ger. If she looked, the empty cavity that had once been her heart would ache unbearably again, as it had when he'd thrown his ring away, as it did every time she thought of that.

With their whole life unsettled between them, how were they going to pull this off? She lowered her hands. "You'd better get her things. I have to check the asparagus."

She busied herself with the remaining dinner preparations.

Later, seated at the dining room table which had been set with their wedding china, lit candles and fresh-cut daisies—another purchase she'd made before realizing they were Dev's favorites, not hers—they ate. Estelle dabbed her lips delicately with her napkin. "This chicken is delicious, dear."

"Thank you. It's Dev's favorite."

Estelle glanced at her strapping son with elegant surprise. "I didn't think you cared for chicken, Devlin."

"That's Derek, Mother," he said, referring to his older brother.

"Well, in any case, this is very good. I'll have to have the recipe for our cook."

Brynna glanced at Dev, but he showed no expression.

"I like what you've done with the walls in here," Estelle said, complimenting the wallpaper and decor. Brynna and Dev had selected the colors and paper for the downstairs and Dev had hired workers to do the paint and pasting. "Those framed scenes remind me of the countryside in Switzerland. Do you remember the little village where we stayed, Devlin?"

"I didn't go to Switzerland with you," he replied. "I was in school in Cambridge that year."

"Devlin was a very bright student," she told Brynna. "But don't let him fool you. He did more backpacking in Europe than he ever did studying in California."

His mother went on talking, but Brynna tuned her out, realizing this wasn't the first time she'd heard Dev correcting his mother's remembrances. Slowly, understanding dawned on her. Dev may have had a privileged upbringing and education, but his parents had been as distant as hers. At least Brynna was close to her sister and brothers; Dev didn't even keep in touch with his older brother.

"I suppose it's too soon to hope you'll be

starting a family," Estelle was saying when Brynna again focused on her chatter.

Brynna's ears hummed. *A family...*

Chapter Sixteen

Dev had carried slices of the golden-crusted fruit pie from the kitchen, and the pause in placing a plate before his mother was barely perceptible. Estelle didn't notice that he swallowed hard before replying, but Brynna did. Could that comment possibly have affected him as deeply as it had her?

"It's a little soon," he replied simply, revealing none of the distress Brynna knew he was feeling. "We're busy with our jobs."

An ache had lodged in Brynna's chest. When Dev set a slice of pie before her, she noted his long fingers, the strength of his wrist and forearm, and she stared at her plate.

"What is it you do at Colby's farm?" his mother asked, oblivious to the turbulent undercurrents in the room.

Dev seated himself before answering calmly. "It's a ranch. I help with the stock, that's what ranchers do."

"Stock, as in cows?"

"Cattle and horses. Colby has an eye for good horses."

Estelle's disapproval of Dev's ranch job had never been a secret. She made no comment, but sampled her pie and glanced at Brynna. "Do you have someone who comes in to cook?"

"No," Brynna replied. "But I did let Dev talk me into hiring a lawn service and someone to do the heavy cleaning once a week. The help is a lifesaver, what with my two jobs."

"Why are two jobs necessary, dear? Surely Dev provides you with all you need."

"I have one more year of residency before I can set up my own practice," she explained. "And I volunteer at the clinic."

"I approve of charity work," Estelle said with a benevolent nod.

"Mother's approval is a rare commodity," Dev said lightly. "Take the gold seal and run, Brynn."

Brynna looked up to see if he was kidding, but his impassive face revealed no humor.

"Tomorrow is Saturday," Estelle said, changing the subject yet again. "Do you two have plans?"

"It'll take me a few hours to fly some friends to North Dakota," Dev said.

Phoebe and Robbie. Brynna had seen Phoebe that afternoon and the girl had told her Dev was making arrangements for them to go home, but that something unexpected had postponed their flight a day. That something unexpected had obviously been his mother's visit. Brynna had no problem waiting another day to release Phoebe. Phoebe had told her that Dev had put up Robbie in a room at a motel in Whitehorn.

She glanced at Dev, thinking of all the kind things he did for people...for her... She learned more about him all the time, was constantly reminded that she hadn't known him at all when they'd...*married*.

"And you, Brynna?" Estelle asked. "What are your plans?"

Brynna brought herself out of her thoughts to reply. "I have to make rounds in the morning," she replied. "That's about it."

Estelle laid down her fork. "Well, then the weekend lies before us, doesn't it? Devlin, you can make your flight while Brynna sees her patients. Afterward, I'd like you to fly me home."

"I can do that, Mother," he replied. "No problem."

"We will have a pleasant family weekend at the estate."

"I need to help here with the fire," he replied.

"Very well, just one day, then. Surely, the two of you can forfeit one day for your family."

The two of them? Brynna met Dev's dispassionate green eyes. His mother rarely called and had only once before invited them to her home. What would Dev's answer be?

"You'll already be flying me to Seattle," she continued. "Brynna will come with us and you can stay a day. One day won't make much of a difference here, but it will mean a lot to me."

Brynna resented the woman's obvious manipulation and her inference that Dev's help didn't mean much. He seemed to take her comments in stride, however, his expression impassive. Brynna had never seen him get upset

about anything—until yesterday. Yesterday he'd plainly shown his anger and frustration—with her.

"I'll leave the decision up to Brynna," he said, resting his elbows on the table and lacing his fingers. "She has her schedule to work around." As he studied her, one eyebrow rose in question.

She didn't know what to say. Was he actually deferring to her preference? Or was he shucking the dilemma onto her shoulders? Both, probably.

"It means a lot to you that we come, Estelle?" she queried hesitantly.

"Yes, it does. I've had the house redecorated, and I want you to see it. And I've planned a small dinner party. I'd love to show you off."

She could say no; it was short notice. But Dev's mother had never asked before, so Brynna would feel bad turning her down. She felt pressured to agree and without being able to discuss it with Dev in private, she didn't know what to do except go along. "All right," she said. "We'll come."

"Wonderful!" Estelle smiled and patted Brynna's hand. "Pack something suitable for the event. It's a dressy occasion, Devlin."

"Of course." He stood, gathering cups and plates.

Brynna helped him, and in the kitchen said softly, "Did you want me to agree?"

"I left it up to you."

She opened the dishwasher, her hand trembling. She'd never been around Dev when he didn't touch her, didn't give her a special smile, didn't have a secret look just for her, and she felt lonelier than when she was here alone.

She had asked him to leave. She had made that decision. Now she tried to remember why, and all she could recall was that she'd been hurt and confused, and he hadn't said the things she'd needed to hear. How would she live through the coming night and day, pretending in front of his mother that all was well, while feeling the isolation created by this emotional wall between them?

They sat in the living room visiting for over an hour before Dev asked if they minded if he turned on the TV to catch the news. When the weather was over, Estelle excused herself for the night and went upstairs.

Brynna couldn't help but look at Dev, waiting for his lead, hoping he had a plan for how they would handle this.

He aimed the remote and muted the volume on the television. "I can fall asleep down here watching the tube," he said. "I have to head out early in the morning, so she'll be none the wiser."

"Whatever you want." Brynna stood.

"Oh, that's rich," he said drily.

She turned to look at him. "What do you mean?"

"Whatever I want? When has any of this been about what I want?"

Warmth flooded her body. Words escaped her mind. She shook her head without comment. Finally, she walked toward the door, then stopped and turned back. "We've agreed to this trip, so we'll make the best of it for the time being. This is for her sake, because we can't bring ourselves to tell her."

"Have you told Melanie our marriage wasn't legal?"

"No," she admitted softly.

"Why not?"

She shrugged and ran a hand through her hair, then propped it on her hip. "I don't know. I just can't admit it, I guess."

He worked his boots off. "You're humiliated?"

Devastated. Heartbroken. Lonely. Her throat ached with the gut-twisting feelings. "Yes."

"Someday we'll have to tell the truth," he said. "People in Rumor know I'm not living here. We'll either have to tell the truth or say we're divorced."

She couldn't think that far ahead. Not right now. Not tonight. Every day was a struggle just to keep herself pulled together for the moment and the day's work. Regret and misgivings welled up and threatened to choke her if she didn't voice them. "Dev, I made a mistake."

Dev glanced up at her, a hundred things going through his mind. What was she admitting to being wrong about?

"About the lawyer," she went on, "and not telling you right away—not showing you the letter."

He tore his gaze away to study the vase of dried flowers on the sofa table. Damned right she'd made a mistake.

"I should have shown you right away. I have this need to control everything, and I started thinking about what I should do and…and, well, you know that. Anyway…I'm sorry that I didn't tell you as soon as I got the letter."

He couldn't get past her initial reaction to the news, though. "Your first thought was that it applied only to you," he said without emotion. "Not to us. You were more concerned about the house than about the fact that we weren't really married."

"I'm just accustomed to handling things," she said, as though that excused her neglect to call him.

"Well, you handled it." Dev's defenses had built a sturdy wall by this time. He had asked *her* forgiveness once, and she had thrown his actions back at him. So much for graceful acceptance and forgiveness, eh? When had their relationship become a test of wills over who could hold the longest grudge? He made himself sick. He knew what he was doing, and he did it anyway.

"Go to bed," he said wearily.

"There are pillows and a quilt in the hall closet," she said.

"I know."

Brynna turned and left the room.

Dev tried to concentrate on the television for a while, then slept fitfully, awakening in the wee hours of the morning. The house was still dark as he crept silently up the stairs and

down the carpeted hallway. The door to their bedroom was closed; he turned the knob and entered the shadowed room.

Brynna lay curled on her side, a hand beneath her cheek, one long leg revealed in the moonlight that filtered through the parted curtains. As he neared the bed, her familiar scent enveloped him, conjuring up images of stroking her silken skin while burying his face in luxurious hair that always smelled of almond shampoo. He loved this woman with a passion that outweighed pride and anger and humiliation.

"Brynn?" he said softly.

"Hmm?" She was a light sleeper. She woke at the sound of her name and leaned up on one elbow. Her fragrant hair fell over the side of her face and she held it back to peer up at him. "Dev, what's wrong?"

"I forgive you." He backed away, turned and shut the door behind him as he left, leaving her staring after him in the darkness.

Brynna glanced at her watch as she left the hospital. Eleven. Seven hours ago, in the black morning hours before dawn, Dev had awakened her to say the words that had been in her

head and on her heart ever since. Starting her car and backing it out of the staff parking lot, she headed for the highway. She'd stared at the ceiling this morning until the rising sun had poked through the blinds to paint stripes above her head.

And then she'd pushed away from the bed, which over the past few weeks had increasingly grown too large and cold, to shower and dress for the day, hurrying to pack a bag for the trip.

Estelle had still been sleeping, and Brynna recalled from her last visit that she didn't arise until around ten, so before Brynna left, she set out a cup and tea bags on the counter where Estelle would spot them.

Now she pulled her phone from her bag and hit the auto dial for her home number. On the third ring, Dev picked up. "Hello."

"You're home."

"I'm here."

Belatedly, she realized her blunder. *Home.*

Chapter Seventeen

"You got Phoebe and Robbie home okay?" she asked to cover her careless words.

"She's a terrible flyer," he said. "Sat with a plastic bag at the ready the entire time."

Brynna smiled, hearing the amused disgust in his voice. "Definitely not your kind of woman."

"Definitely not."

Did he still think Brynna was his kind of woman? she wondered. "Is your mother wearing a path in the carpet waiting for me?"

"No, I made her sit and watch a movie."

She never knew when he was joking. "Which one?"

"*Monsters, Inc.* She loves it."

Brynna couldn't help the laugh that escaped at the image of Estelle watching one of the kids' DVDs. "You're putting me on, right?"

"Serious as a heart attack. She was making me nuts, so I sat her down with a bowl of popcorn."

"Sounds like babysitting to me."

"You've got that right." Obviously he wasn't saying more because his mother could hear him.

"Tell her I'm almost there. My bag is packed. Did you remember to pack a suit?"

"Yup."

"Okay, well, I'll see you in a few minutes."

"The plane's fueled and ready, we can take off any time."

"Bye." Brynna dropped the phone into her bag, wondering what the next several hours held in store.

Estelle was indeed ready, and Brynna barely had time to change and freshen up before they were on their way to the airfield. "I have guests coming, and a dozen last-minute arrangements to check on," she said.

"You said this was a small dinner party,

didn't you?" Brynna asked, knowing the senior Holmeses had a cook and a housekeeper and that Estelle used a party planner regularly.

"Yes, dear, but one must stay on top of the help at all times. I'm a stickler for details and everything must be just so before the guests arrive."

They reached the airfield and Dev parked. A Queensland heeler and a black lab darted from the hangar and greeted them with tails wagging and tongues licking.

Estelle drew up both hands against her chest and cringed. "Good gracious! Where did those creatures come from?"

"They adopted Lee Henderson, the guy who owns the airfield, a while back," Dev explained.

Brynna knelt to stroke the dogs' heads and scratch behind their ears. "What's your name, boy?" she asked the heeler.

"That's Spice," Dev told her, giving the black lab the attention she was seeking. "She's Sugar."

Brynna laughed. "Cute. Sugar and Spice."

"Are we going to get on the plane or stand

in the sun all afternoon?" Estelle asked, her voice a disdainful accusation.

Dev opened the door, situated the folding stairs and helped his mother aboard. Once they were all seated, he started the engines, ran through his preflight check and handed the women headsets.

"Will you be showing another film?" Estelle asked.

Brynna laughed aloud at her dry humor, and even Dev put a grin on his face. The dimple in his cheek made her heart flutter foolishly. "I heard you liked *Monsters, Inc.*," she said to Estelle.

Estelle lifted one brow in the same manner that Dev used so often. Her expression was haughty, however, where his was flirtatious, as she asked, "Is that what he told you?"

How had Dev become so calm and easygoing with a mother like Estelle? He hadn't really spent that much time around her, Brynna remembered, adding another revealing link to the chain of explanation regarding how his upbringing had shaped him.

Brynna napped as best as she could with the engine noise and motion of the aircraft. She was exhausted from a near-sleepless night and

a busy morning. In a state of half-consciousness, she again saw Dev standing in their darkened bedroom, heard his familiar voice using a tone she didn't recognize: *I forgive you*.

No preamble, no explanation, just the words. The fact. He forgave her. She'd made him so angry, he'd thrown his wedding ring into the lake. But he'd forgiven her.

She looked over at him through slitted lashes. He wore his sunglasses and headset, his buoyant yet preoccupied expression one she'd seen only when he was piloting a plane. An occasional glance at the dials and gadgets on the dash showed diligent watchfulness.

This was where he loved to be, what he loved to do. She had sometimes felt jealous of the pursuit, as though flying was a threat to her the way another woman would have been.

Had he sometimes felt that way about her hours at the hospital—at the clinic? If he had, he'd never let on.

I forgive you. Coming from him in the wee hours of the morning. Had he contemplated those words all night? Had he lain awake as she had?

Just then, Dev glanced her way and caught her studying him. She couldn't see his eyes

because of the aviator glasses, but she felt his gaze on her face, her breasts...she knew how he looked at her...with appreciation and desire. She wished she could see his eyes, know for sure what lay within their green depths. Her body tingled instinctively at the thought of him looking at her that way.

If they were alone—if this was a few weeks ago, she would have reached over and removed his glasses to see the look in his eyes. She would have leaned toward him for a kiss...suggestively touched his thigh through the denim of his jeans, making promises for later.

Dev looked away and Brynna experienced the loss. How dismal to think of never feeling his arms around her again, never lying cuddled naked and entwined, never sharing fiery kisses or tender caresses, never hearing his utterances of praise and appreciation...the loss was so great, she experienced heartbreaking grief all over again.

She hadn't thought this through, hadn't realized the enormity of what she'd done in asking him to move out of their home. Every day that passed without him showed her the bleakness of her future without him.

She had believed that she'd done the best

thing—that knowing he couldn't commit to a family was more painful than losing him altogether. Had she been wrong?

Some time later, the sound of Dev radioing ahead and getting clearance at the airstrip broke into her thoughts. Seattle was overcast, but not rainy, and the weather when they got off the plane was fair.

Estelle's driver was waiting for them with a black Lincoln Towncar, and within minutes they were headed for the Holmes estate.

"You'll stay in Devlin's former room, of course," Estelle told them as they entered the enormous marble-floored foyer. "I think you'll like what I've done with it. I've made a few changes suitable for a married couple."

Ignoring Dev's eyes, Brynna managed a smile and proceeded ahead of him up the stairs. He stood aside with their bags while she entered the room. "A few changes," she said. The room was completely transformed. A polished, antique brass sleigh bed, piled high with a gold-and-jewel-toned comforter and pillows, was draped at the corners by gauzy curtains hung from the ceiling. Brynna walked over to the full-size fur throw at the foot of the bed and stroked the luxurious mink. "Is it real?"

"Probably acrylic, look at the back."

She turned over one edge. "Fake."

"Faux," he corrected. "Sacrificing animals for profit is politically incorrect."

"Of course." The furniture pieces, including a huge armoire, were distressed black with antique brass hardware and designed with hand-painted birds and foliage.

"You'd never know I'd ever been here, would you?" he said drily.

"It makes a nice guest room." She fingered the gauzy material draped from the ceiling.

"It would make nice decor for a sultan's tent," he commented.

Brynna chuckled and kicked off her sandals, feet sinking into plush tobacco-colored carpet.

He examined two pedestal boxes with leopard-skin designs and scrolled brass lids. "She didn't pick this stuff out herself."

Brynna opened her overnight bag and placed items on the bathroom vanity beside a bronze sculpture of a near-naked maiden dressed in copper leaves. "Whoever picked it out has... unusual taste."

"And a fat bank account—now."

Dev had hung his suit and her dress in the closet and placed the rest of their items in

one of the huge bureaus when she joined him again.

Their eyes met.

They were alone. With an enormous, lushly appointed bed four feet away.

Chapter Eighteen

Brynna pointedly ignored the bed.

I forgive you.

The image of him coming into their bedroom and waking her to say those words was impressed on her mind for all time. She hadn't acknowledged him, and they hadn't spoken of it again...they hadn't been alone. Until now.

I forgive you.

How much of an internal struggle had it taken to force him up those stairs and into that room with those words on his mind?

He had never said he didn't love her. Had never said he didn't want her. It had been his

actions that had spoken to her more plainly than any words could have. She hadn't come first. Her pregnancy had been an inconvenience.

Had she been too hurt to listen to what he was really saying?

"We have time for a little sightseeing or a drive before we have to get ready for dinner," he said, obviously ready to get them out of this room.

"I'd like to take a walk," she suggested. "See the Sound, maybe take a ferry."

"Can do," he agreed.

They changed into shorts and cotton shirts, and Dev backed a red convertible sports car out of the multicar garage and headed for Puget Sound. The sun had broken through the clouds and warmed Brynna as well as lifting her spirits. The landscape was green and lush in contrast to the dry browns of drought-stricken Montana, the air blue and clear, reminding her of the fire threatening her hometown.

Up ahead the docks and the Sound came into view, accompanied by the sounds of gulls and air horns.

"Do we have time for a ferry ride?" she asked Dev. "It was just a suggestion."

"It's only about thirty-five minutes to Bainbridge Island. We'll stroll a bit and then come back. We have plenty of time."

He found a parking place, bought them each a cappuccino from a small shop, and they boarded the ferry. Dev paid and led her up an escalator to the sun deck. Minutes later, they were sailing. Brynna sipped the delicious sweet brew and enjoyed the sun on her face, the throb of the engine and the sound of the lapping water. Gulls swooped and cawed, some dipped toward the shoreline while others followed the ferry.

The incredible skyline took her breath away. Lush vegetation lined the shore as far as the eye could see. "I feel like I've stepped into a postcard," she said.

"If I had a camera, I'd make *you* a postcard," he told her, leaning against the back of the bench and studying her. The wind blew a tress of hair into the corner of her mouth and he leaned toward her to drag it away. She studied him, surprised at the touch, but still couldn't see his eyes. Her cheek tingled where his finger had grazed.

Dev had never seen anything as beautiful as Brynna, her honey-blond hair shin-

ing in the sunlight, her skin glowing from the warmth of the afternoon. The day was as near-perfect as he could expect, flying with her, taking a drive, sailing across Puget Sound on a ferry...although a couple of things could have made the day better. They could have made the flight alone... They could have ripped off their clothes and set that sultan's bed on fire...

He studied her from behind the covert safety of his sunglasses, appreciating the soft curves of her breasts beneath her thin shirt, noticing her sleek thighs in those sexy white shorts. His perusal coming back to her face, he imagined the remembered pleasures of those full pink lips. More than anything, he wanted to touch her...even just a simple caress of her cheek or her hand...but he no longer felt free to do so, and the loss was another torture to endure.

She returned the examination with a question in her expression, and, taking him by surprise, she leaned forward, removed his sunglasses, then sat back and continued her perusal.

"I like to know when you're looking at me," she said.

"I like to look at you."

He gave her curvy body another lazy once-over, ending with his attention on her mouth. Her cheeks flushed with more color than the sun and wind could have caused in such a short time. Was she embarrassed...or excited? He had learned to recognize the signs of her arousal, and noted them now.

Her lips were parted, her cheeks blushing... and through the fabric of her shirt he identi-fied the hardened peaks of her nipples. She saw him looking and blushed even redder. She was anything but immune to him, he thought, privately satisfied. They'd been hot for each other since the moment they'd met, and just sitting here looking at each other had them both aroused.

She handed him his sunglasses and changed positions on the bench, looking across the water and leaning forward, one palm on ei-ther side of the seat, as though she could hide her reaction. She couldn't. He knew.

Dev slipped his dark glasses back on and turned his attention to the scenery. This was turning out to be a very promising day.

Arriving on Bainbridge Island, they strolled for awhile, stopping for ice-cream cones, then Dev bought fares and they boarded a ferry to

return. He watched Brynna enjoy the treat, licking dollops of strawberry ice cream, and the sensual sight affected him physically.

He missed her. He missed seeing her fresh out of the shower, her hair wet and her skin pink and moist. He missed sleeping curled around her, her fine bottom tucked into his groin. He missed the way she laughed at his teasing, the way she smiled her sleepy thanks when he brought her a cup of tea in the evening. He missed making love to her. And that affected him emotionally.

She caught him looking at her. "What are you thinking?"

"I was thinking about that little sound you make."

"What sound?"

"Sort of a catch in your throat, sort of a sob almost…you do it every time…"

She knew what he was talking about. She lowered the cone. Her gaze, now a sultry sienna, raked his features and focused on his mouth.

He smiled.

She swallowed.

He cheered silently. She wanted him as badly as she ever had. And he loved her so

damned much he'd *walk* back to Montana if it would prove anything to her.

His grin widened. He was glad they'd come to Seattle. He had her all to himself for another day—well, aside from fifty ritzy party guests and his parents—and a lot could happen in a day...and a night. A lot.

Back at the house, Dev gave her privacy to shower and dress for the party by taking his clothing and shaving gear to another room. Once ready, he shrugged into his jacket and descended the stairs to survey the layout. At the bar, which had been set up outdoors near the lighted pool, he mixed two drinks and carried the glasses up.

Brynna had finished dressing and was fastening the strap on a white high-heeled sandal adorned with a fabric rose when he entered the room. Leaning forward with her knee bent, her foot propped on an ottoman, the entire length of her leg was exposed. He stared. She finished the task and straightened, the white dress disappointingly draping to cover her legs.

The clingy white garment sort of wrapped across itself in the front and looked to be

barely held closed at her hip with a white satin rose like the ones on her shoes. Some sort of appliqué adorned the fabric at her hip, and ribbons hung from the flower.

The style gave the impression that the seductive thing would open at the least tug on those ribbons. His mouth went dry.

The dress was long, ankle-length, but when she walked across the room, the side opened to again reveal the long length of her leg, all the more enticing because he knew the hidden delights firsthand.

She stood before a mirror to adjust her gold earrings, but instead of looking at herself in the reflection, she stared at him. He'd chosen dark trousers and a matching jacket with a soft shirt that didn't require a tie. He remembered the glasses in his hands and handed her one, their fingers brushing.

"Thank you."

"To all the sultans in Seattle," he said, gesturing with his drink to the room in which they stood.

"May we be long gone before they discover their fur is faux," she added, raising her glass in the toast.

He had started to take a drink and laugh-

ingly choked on the first sip. He reached into his breast pocket for a handkerchief.

Smiling, Brynna hurried to take the monogrammed handkerchief from his fingers and dab his chin, then the lapel of his jacket. She smelled like almond shampoo and woman and sultry carnal pleasure, and he could have taken her right then and there, so immediate was his arousal.

But it was too soon, and the night lay before them. He intended to enjoy it. And her.

"We could slip out back and walk in the gardens before we have to mingle with guests," he said. "The bar's out there."

"And you know what a big drinker I am," she replied.

Grinning, he ushered her to the door. He knew what had happened the last time she'd had a few too many drinks, and he hadn't minded a bit.

She linked her arm through his and a buoyant expectation rippled through him. For the first time in weeks her eyes were twinkling and she wasn't looking at him as though he'd intentionally ripped out her heart and left her bleeding to death.

The multilevel pool was lit from within, and

strings of multicolored lights had been draped between poles that lined the perimeter of the flagstone-paved pool area. The pool had a waterfall, with a private heated basin surrounded by greenery on an upper level. "Want to sneak a swim later after everyone is gone?" he asked.

"Maybe," she replied without committing.

Sounds of instruments warming up caught their attention. Brynna looked at him with a question.

Dev stepped to the French doors and spotted a tuxedoed string quartet.

"A small dinner party, huh?" Brynna said from beside him.

"You should see the really big shindigs," he replied.

It wasn't long before guests began arriving. Dev politely joined his parents to greet the guests and introduce Brynna. Every time he said "my wife" he avoided her eyes. She smiled and made small talk and received appreciative glances from all the men.

Dev spent the requisite time talking to his father, hearing how well his brother was doing and how Derek was using his degree and helping out with the business. Dev deflected the

usual feelers about when he would be moving back to Seattle and joining their ranks.

"Why isn't Derek here this evening?" Dev asked.

"He's handling some business in Los Angeles," his father replied. "There's another meeting on Monday, so he stayed the weekend."

"His excuse must have been more convincing than mine," Dev remarked. Excusing himself, he guided Brynna to the buffet table inside. They made their selections from the elegant fare, seated themselves to eat and shared a glass of wine.

As darkness fell, subdued lighting came on. The orchestra played, and Dev enjoyed Brynna's company and this time alone without controversy. For a change, the atmosphere felt good between them. He could almost imagine they could work things out.

When the musicians moved outside, Dev took Brynna's hand and led her gracefully across the flagstones. A few other couples joined them under the stars. Watchful of her balance on the uneven surface, he held her close. How different this was from the times they had danced at Joe's Bar and even the one time at a dinner club in Billings. No jeans or

peanut shells here; no pool balls clacking in the background.

It was a romantic setting and an idyllic evening for both of them—no smell of fire, no beeper, no real-life intrusion. They would return to all that soon enough; for tonight there were only the stars above and the dreamlike strains of the music...just the two of them.

"I must remember to thank my mother for manipulating us into coming," he said.

"I enjoyed this afternoon," she replied.

"And tonight?"

"And tonight."

He pulled her close and inhaled the intoxicating scent of her hair. He'd missed her more than he could ever express—needed her more than he ever thought he would need a woman.

"Are you enjoying this evening, too?" she asked.

"Very much."

"Even though you had to dodge bullets earlier?"

"I'm used to the old man," he replied. "The inquisition was well worth this."

And it was. He'd missed holding her and enjoying this closeness. He took advantage of every moment. As they danced, he remem-

bered the sight of her fastening her shoe, the exposed length of her silky thigh, and he couldn't control thoughts of touching that length of skin, pressing kisses to the inside of her knee.

His body reacted, and since he held her so close, she knew.

Chapter Nineteen

She looked up and met his gaze. Her eyes were dark and luminous. He didn't care that he couldn't hide his desire.

"You are so incredibly beautiful and sexy, Brynn," he said softly, and she smiled.

A few at a time, the guests left until Dev and Brynna were the only ones left, but they didn't seem to notice. Dev kept her dancing until the musicians packed their instruments, and then, finally, he realized the music had stopped. He took her hand and led her into the garden, the path lit by torches.

Brynna started for the concrete bench, but

Dev pulled her back toward him. She came up against his chest and gazed up.

"You're the most beautiful thing I've ever seen," he told her, delighting himself in the warm feel of her back beneath the filmy dress. "I haven't been able to take my eyes off you all day."

She didn't reply, but she didn't draw away. Brynna placed her palm against his shirtfront and leaned into him, her soft breasts crushed against his chest.

He cupped her bottom and brought her flush against him, showing her again how she had affected him.

Brynna raised her other arm to his shoulder and he leaned forward, meeting her lips and crushing her mouth beneath his in a hungry exploration. He traced the crease of her lips with his tongue and she opened to him, taking his tongue into her mouth the way he wanted her to take the rest of him into her body.

Crickets chirped a chorus against the soothing sound of the waterfall, and the night closed in around them. At that moment under the stars, they were lovers with no past, no future, existing only in this pulse-raising moment.

Inching her silky skirt upward, he gathered

the fabric until his fingers found the warm smooth skin of her bottom. He stopped kissing her to ask, "What are you wearing?"

The scrap of underwear left her cheeks bare for his exploration, and he took advantage, molding his hands to them while holding her firmly against him. "Or maybe what *aren't* you wearing is the question."

Brynna raised her arms to his shoulders, straining upward for another kiss, and framed his face with her hands. She groaned when he ground his hips against her. She let her head fall back and he ran his tongue along the skin of her throat, nipped her shoulder and tasted her earlobe.

Dev spanned her hips with his palms, stroked upward and cupped her breasts. "Is that little scrap of underwear all you have on under this dress?"

"Uh-huh."

"If I untied those ribbons, would the front open?"

"Uh-huh."

He reached for the rose at her hip, but she caught his hand. "Not here."

"Not here" meant she was willing for him

to untie it elsewhere, so he grabbed her hand and urged her toward the house.

"There you are!" Estelle spotted them once they were inside. "I wondered where you'd run off to."

Dev moved Brynna in front of him and spoke to his mother over Brynn's shoulder. "We had an early day. We're ready for bed."

"Did you enjoy yourselves?"

"Oh, the party? Yes, it was very...uplifting," he said.

"Everything was very nice," Brynna added, her cheeks flushed.

"Good night, dears. Sleep well." Estelle waved them off.

Keeping Brynna in front of him until they reached the stairs, Dev then tucked her hand into the crook of his arm and led the way, ushering her into their quarters and closing the door with an eager click.

Someone had turned down the covers and two muted lamps burned on the wall on either side of the bed.

Dev reached for the ribbons at her hip, untying the bow and peeling the fabric apart. There was a small hook, as well, which he slipped out of its mooring. The dress wrapped across

her breasts and was hooked on the opposite side as well, and he figured it out impatiently.

The fabric skimmed down her body to pool at her feet, and he bent to help her step out of it, then draped it over a chair. She wore nothing but the V-shaped white thong and those shoes with the white roses. She was all legs and satin skin, better than his memory, better than his imagination. Her breasts were pink-tipped and perfectly shaped. Her nipples pebbled and he touched one with the tip of his finger, kissed her shoulder, stepped behind her and ran his fingers down her spine. She turned her head to see him over her shoulder. He stepped against her, pulling her back along his length, cupping her breasts, inhaling the scent of her hair.

Brynna reached an arm up and back to slide her fingers into his hair and nuzzle her face along his jaw.

"Are you sure this time?" he asked, needing to be certain. "I don't want you to feel later that you've made another mistake." Half afraid of what she'd say, he waited for her reply.

She kissed the underside of his chin. "I'm sure."

He slanted his head to kiss her lips, and she

responded with a sigh. As if impatient for more satisfying contact, she turned in his arms to face him and opened his jacket. "This isn't fair," she said. "You're having all the fun."

He obliged her, removing his coat and shirt, and his blood hammered when she unfastened his belt and trousers and reached inside to fill both hands.

Dev gritted his teeth against the intense pleasure and allowed her purposeful caress for as long as he could stand it.

Stopping her by gently grasping both wrists, he moved her to the edge of the bed. She scrambled to the center and watched him remove his shoes and socks so he could shuck his pants. He joined her, pressing her against the mattress and kissing her before suckling her breasts until she whimpered.

She sat up and reached for the buckle of one shoe, but he stopped her. "No, just these," he said and eased her back to slide the thong downward. With a seductive smile, she helped him. He kissed her ankle, her calf, gazing with appreciation at the delights revealed only to him.

Leisurely he tasted the inside of her knee, the length of her thigh, knowing he could make her

impatient, and taking gratification in drawing out her anticipation as well as his own. Her desire increased his, and he soon had no thought but pleasing her. He loved her with his hands and mouth, pausing when he knew the sensations were too intense, prolonging when she caught her breath and her entire body quivered.

She was so exquisite, her reactions so spontaneous, his heart raced. His love for her was boundless, and he wanted to worship every inch of her, give himself to her unsparingly and know her love the same way in return.

When at last he covered her with his body and joined them, he was trembling with unspent need. She welcomed him with kisses and warm embraces, clinging to his back and shoulders, holding him tightly with her knees. Dev lost himself in the sublime indulgence of her body, grateful as always that her fiery appetite matched his. Finally, grasping his hips, she met his thrusts until their passion was spent.

Dev collapsed at her side, his head on her shoulder. She caressed the hair away from his temple and placed a kiss on his closed eyelid. He opened his eyes to see her, hair disheveled, skin aglow in the lamplight, a lazy smile on

her kiss-swollen lips. She was a woman well loved, and he took satisfaction in the knowledge that she was his, and that he was the one—the only one—to give her such pleasure.

She brought her knee up. "Can I take these off now?"

He stroked her calf while she unbuckled her shoe. "Oh, I don't know, if you leave them on, you can wear them to breakfast."

She dropped one shoe off the side of the bed and worked on the other. "Wonder what your mother would think."

"That you didn't pack tennis shoes?"

She laughed and discarded the other before stretching languidly. Dev stroked her velvet skin and when she turned into him, they snuggled. For the first time in their relationship, he hadn't done anything to prevent conception. Had he been purely caught up in the moment or did he unconsciously want her to get pregnant again? How unfair would that be, when their relationship was so unstable? Did he think he could bind her to him?

Should he mention it?

She had folded herself into his embrace, rubbing his bare hip and occasionally pressing a soft kiss against his chest. She raised

her hand to his neck and kneaded the muscles until he sighed. She knew as well as he what could happen, better because she was an obstetrician, and if she hadn't said anything, he didn't want to be the one to destroy the tentative bond they'd restored tonight.

Brynna straightened in his arms, pressed her face against his neck and hugged him tightly. He wanted to stay here forever.

Dev threaded her hair back, cupped her chin and raised her face for a kiss. She met his lips tenderly at first, but with increasing passion. Moments later, she slid her leg across his body and raised up to straddle him. She sat motionless, gazing down into his eyes.

Dev's reaction was immediate, and he watched appreciation flit across her features in the dim glow of the lamps. She moved sinuously to ease his swollen thickness inside her. Her eyelids fluttered shut.

"Look at me," he said, his voice rough.

She did.

Ardor growing, he watched her, her hair sexily mussed, her dark eyes luminous with desire and what he hoped was still love. He stroked her thighs and hips, appreciating the lovely vision she made above him. Gauzy fab-

ric surrounded them, filtering light and enclosing them in their own private world. She began a slow seductive rhythm. Brynna, beautiful Brynna, this smart sexy woman was his, and he couldn't bear to lose her.

If it was unfair to hold her with this wild physical attraction, did he care? It had been this way between them since the moment they'd met, and it had worked fine for most of a year. Better than fine. They'd been happy.

They'd been in love.

She knew just how to turn him inside out. He closed his eyes and concentrated on holding back.

"Dev," she said breathlessly, "look at me."

He did.

She knew what she was doing. And she was relentless.

He moved his hands to her breasts and gave himself over to her, to the sensations, to the inevitable. His climax spurred hers and she throbbed around him, finally falling forward and lying on his chest as though she hadn't a bone in her spent body.

He drew her hair aside and stroked her shoulder.

And together they dozed....

* * *

Brynna awoke to feel Dev curled around her naked body, his warm skin a tactile delight everywhere they touched. The dim lights were still on, and she glanced around the gauzy drape at the small clock on the night table to see it was a little after two. Perhaps the light had awakened her, or maybe it had been the seductive joy of having Dev so near and so accessible she could touch him anytime she pleased.

And it pleased her now. She reached back and ran a hand across his hip.

Rousing, he made a sound of appreciation deep in his chest and pressed himself closer to her.

She was awake now, and she moved to adjust their entwined limbs, rolling to her back and seeking his face.

His green eyes met hers sleepily. "What time is it?"

She told him, and his eyes drifted closed.

"Still want to take that dip in the pool?" she asked.

His eyelids flew open.

Chapter Twenty

"Do you?" Dev asked immediately.

"Uh-huh."

He straightened and stretched. "You'll either kill me or keep me young," he said with a roguish grin, and ran a hand through his rumpled hair, mumbling something about brain damage.

"Do we need suits?" she asked.

"Just something to cover up until we get there." Not bothering with underwear, he shrugged into his trousers and Brynna pulled on a robe. Dev found towels and they slipped out through the sliding glass door to a balcony and down a set of stairs.

She'd never been to the upper pool before, but Dev led the way up stone stairs lit by land-scaping lights, and she followed. It was more of an enormous hot tub than a pool, surrounded by green foliage and hidden by cleverly arranged stone walls. Dev opened a concealed control panel and the water began to bubble enticingly.

A lovers' paradise. Dev removed his trousers and made his way down the stone stairs into the water, her admiring gaze following. What a seductive month he could adorn in a hunk calendar. When he stopped and turned, the water reached his waist. He beckoned to her. "Come on."

She dropped her robe and followed him in. As she descended, the warm water swirled around her ankles, knees, hips, belly, surrounding her in a sensual caress. A shiver ran up her spine.

Dev met her and pulled her against him for a sound embrace. "Couldn't sleep?" he asked.

"I was asleep. I don't know what woke me."

"I know what woke me," he said. "And I'm not complaining."

She smiled and stroked his hip as she'd done

then. "This isn't really much exercise, is it?" she asked. "I was thinking a swim."

"You can swim in the pool if you like. Actually, it's pretty refreshing after soaking in here. But this feels good on the muscles." He guided her to a ledge that served as a seat, where the jets pulsed warm water around their bodies. "See?"

She leaned back and enjoyed the soothing sensations. Dev sat beside her to do the same. "Mmm," she purred. "Physical therapy with style."

"Think you'd like one of these?" he asked.

She grinned. "I can see it now. Outside our back door and everyone driving by on the highway could wave."

He chuckled.

Brynna realized she'd just said "our back door" and he hadn't reacted as though she'd blundered. There were so many things she couldn't mention, subjects they couldn't talk about now, things like "their house." Certain words had become forbidden to their conversation, words like *marriage, baby, husband, wife...pregnant.*

A couple should be able to talk these things through without hurt feelings and anger,

shouldn't they? There had to be more to a comfortable, meaningful relationship than sex. They had the sex part, that had never been a problem.

Or maybe it *was* the problem. Maybe they were so crazy hot for each other that they abandoned reason and common sense. Maybe sex had pushed their relationship too far too fast. Perhaps if they'd taken time to discuss their mutual goals and really *understand* each other, they would never have decided to get married in the first place.

They'd have enjoyed a brief affair, and when things got shaky, they'd have gone their separate ways.

No. Even if they'd been simply having an affair, Brynna might still have become pregnant, and the same thing would have happened... they weren't even married for real anyway, so what was the difference now?

"Brynn?"

His voice brought her out of her reverie. "Hmm?"

"What are you thinking?"

Nothing she could mention while still enjoying the rest of their time together. "Purely carnal thoughts, I assure you."

"Really." He slid beside her, hip to hip, and slipped his arm around her.

Brynna turned toward him, and, quite naturally, straddled his lap. She wrapped her forearms behind his neck and he pulled her forward to kiss her. The water pulsed against their skin, bubbling and eddying in a sensuous prelude.

Perspiration had dotted Dev's forehead and temples. Brynna scooped a handful of water and trickled it over his head. She continued to wet his face, pausing to caress his temples and jaw. After slowly running her thumb over his lower lip, she kissed his mouth. He met her tongue with his and deepened the kiss.

Kissing Dev was a rush every time. Sex with him was hot and intense and all-consuming, and she would never have enough of him. The man did something to her that intensified her hunger and multiplied her enjoyment. He was an aphrodisiac, a stimulating drug that once in her veins took control and ran its course. He embodied her every fantasy and he was hers to do with as she wished.

At one time, she wouldn't have considered herself sexy. She was educated, talented in her profession, hardworking and considerate. Sexy

was for other women, for girls who knew how to flirt with boys, for women who enjoyed dating and men. That hadn't been her.

But once she'd met Dev, all that had changed. The way he looked at her, the way he made her feel—the way she felt and the things she thought when she was with him—changed her. Dev made her sexy. She became adventurous; she created fantasies and he fulfilled them; she was a physical, highly responsive partner, and Dev had brought that about.

Brynna wiggled on his lap, creating friction, wet skin to wet skin, and eliciting the desired response from Dev.

His nap had apparently done wonders, because he rose to the occasion handsomely, joining their bodies and allowing her to take her pleasure leisurely. He kissed her, withdrawing from time to time to rake his gaze over her face and breasts, to trickle water from his fingertips to her nipples and watch it run off.

Brynna felt beautiful and seductive when he looked at her, his green eyes glowing with passion and appreciation. A sad, sweet regret ripped at her heart and brought tears to her

eyes, so she quickly leaned forward and kissed him so he wouldn't see.

He wasn't really hers, and everything they'd built their relationship on had been yanked out from under them. He still wanted her in this way, but what about a commitment? What would happen when they had to face the hard cold reality of day and decide what to do from here on out?

Life wasn't just ferry rides and moonlight dances. Life was also work and hardships and family problems. And so far they'd been unable to handle any of the trials. If she lost Dev, she didn't know how she would face an empty life.

Sensing her urgency, he adjusted their positions and helped her movements by grasping her hips and leaning her back to nip her neck with his teeth and then follow each bite with a hot kiss. Stars exploded behind her eyelids. Waves of pleasure throbbed through her body.

Dev uttered her name and found his release swiftly.

With a splash that erased her tears before he could see them, Brynna pulled him down into the swirling water.

* * *

They slept in Sunday morning, not that Estelle would have noticed, because she didn't come down to the patio for coffee and quiche until after ten herself. Dev and Brynna had been there for about twenty minutes, sharing the newspaper with Dev's father.

"You two look positively refreshed," Estelle said, pouring herself coffee and taking a seat at the glass-topped table. "Time away obviously did you both good."

"I do want to thank you for coercing us into coming," Dev said, laying the sports section aside. He got up to help himself to more of the egg dish and a slice of melon. "We've had a great time."

Brynna had finished her breakfast, and now pushed her plate aside. This was where she should return the invitation and welcome Dev's parents to their home anytime. She held her tongue. The future was too uncertain and nothing had been resolved.

"How is your family, dear?" Estelle asked. "I only met your parents one time, at the reception you held for your wedding."

"That's the last time I've seen her parents, too," Dev said, resuming his seat.

"I couldn't tell you where they are right now," Brynna added.

"They travel extensively?"

"Yes." Brynna allowed Estelle to imagine a jaunt along the coast of France, rather than extended camping in a Winnebago. Brynna met Dev's gaze and he grinned, obviously thinking the same thing.

"And the rest of your family?"

"My sister's family is fine. My nephews are growing like crazy. My brother, Kurt, is a pharmacy tech in Rumor and Tuck will be going to college this fall." She hadn't talked to her youngest brother for a couple of weeks and felt guilty about abandoning him. "I should call and see how he's doing."

"He's doing great," Dev told her.

She glanced over at him. "You've talked to Tuck since flying him to California?"

"Uh-huh. He got settled in the apartment and is working full-time at a video store until school starts."

"An apartment without roommates?"

"Yes," Dev replied.

"I'm off to the office," Dev's father said, standing and excusing himself.

Brynna looked up, his abrupt departure a

surprise. Maybe he simply had a pressing business appointment.

"And you'll have to excuse me, too," Estelle piped up. "I have a brunch to attend this morning." Estelle kissed the air beside Dev's cheek, then blew a kiss in Brynna's direction. "Bye!"

Dev and Brynna were left alone on the patio.

Chapter Twenty-One

Brynna didn't want to think of their hasty leave-taking as rude, but the woman had practically insisted they come for this visit, and now, after five minutes of conversation, she had removed herself for another, obviously more important, engagement.

Dev ate his breakfast as though nothing unusual had happened. And Brynna realized their running off hadn't been unusual. Dev was as used to his parents' disinterest as she was used to hers. The Holmeses were more like her parents than she'd ever thought, they were simply in a higher economic class. The

revelation gave her further insight into Dev's personality.

She resumed their conversation where it had been interrupted, asking. "What's this about Tuck having an apartment of his own?"

"Sharing space can be trouble," Dev replied. "Tuck'll be better off on his own. He could get stuck with some really sorry roommates and not be able to do anything about it because of a lease or because he needs help with the rent. This is better."

Brynna stared at him. She'd been so self-involved for the last couple of weeks she hadn't paid much attention to what was going on, but apparently Dev had been in the middle of things. "I meant to help him with a place."

"It's okay, you had other things on your mind. You had yourself to take care of."

"You paid for his apartment, didn't you?"

"Actually, it's my apartment. I'll stay with him when I'm on the coast," he replied with a shrug.

Brynna had made a point of not accepting Dev's money for herself. It was a point of pride. She'd made it this far on her own, and she was proud of her accomplishment. But she'd struggled, and her brothers had struggled

along with her. She and Kurt had both attended college on grants and student loans, living in crowded dorms and working part-time jobs to pay for books and food.

Because of Dev's generosity, Tuck would have it easier. He wouldn't have to scrape by as she had. But she had let down her brother, and someone else had picked up the slack; no, not just someone else—Dev.

Dev's dubious expression revealed his uncertainty over her reaction. Was she so stubborn and proud that he anticipated anger? Maybe a while back she would have reacted differently, but today, at this moment, she felt nothing but humble appreciation for his kindness.

"Does he have everything he needs?" she asked.

He nodded. "It's okay that you took care of yourself first," he told her. "I admire your dedication to your sister and brothers, Brynn, it's something I don't have with my family. But sometimes you need to let others help— or even let them find their own solutions to their problems—or make their own mistakes."

"They never had parents to take care of

them," she said defensively. "They deserve someone to look out for them."

"Neither did you, and you turned out okay."

She turned that one over in her mind and studied him.

"Maybe if I'd had to work as hard as you did, I'd have turned out to be more responsible," he said. "Who knows?"

"You're not irresponsible, Dev," she stated truthfully. "You've just never had people relying on you all the time the way I did. It takes some getting used to."

"Your brothers and sister have turned out okay, too," he told her. "But maybe Melanie and Tuck rely on you so heavily because they've never had to rely on themselves."

"You're full of surprises," she said, and placed her hand over his on the table. "I'm the one who took the psychology classes, and you're the one counseling me."

Turning his hand to cradle hers, he grinned. "Who said I didn't take psychology classes?"

The flight home was more relaxed than the flight to Seattle had been. There were still things they hadn't worked through, but this temporary respite was going so well that nei-

ther seemed inclined to wake the sleeping giant. They made small talk, touched often and smiled.

But the closer they got to home, the less they spoke and touched and the more they avoided looking directly into each other's eyes. By the time they reached the airstrip, they had stopped talking altogether, and a heavy cloak of reality had dropped over them.

The sky was still dark with smoke and soot, and the air held the acrid stench of acres of timberland going up in flames.

They stood on the landing strip, and Dev stared at the sky, his face once again unreadable.

"You're going, aren't you?" she asked, already knowing the answer.

"I have a business transaction to handle first," he replied, "and then I'm going."

And though she wanted to touch him, she kept her distance. They were back in Rumor now—back to their real lives.

That night, alone in their bed, Brynna remembered how he'd driven her car home and carried her bags inside. After transferring his flight bag to his truck, he had stood in the

driveway, the renewed tension between them awkward.

"I guess we'll have to talk later," she said. "After the fire is taken care of. Decide what we're going to do."

Not a word of the lawsuit or their illegal marriage had been spoken between them the entire weekend. They had temporarily swept all that ugliness aside and ignored it. But it was real, and it was their life, and they would have to deal with it, no matter how much they wanted to ignore it.

Dev studied her for a moment before turning to open his truck door. From the seat, he took his black Stetson and placed it on his head, making a habitual adjustment. "Later then," he said.

So much hung in the precarious balance between them, but neither seemed willing to voice the issues that were driving them apart. Her chest ached with the loss of the easy familiarity they'd shared for the past two days.

He looked at her as though he wanted to say more, as though he was torn between speaking or leaving well enough alone. Finally, he had bade farewell with a nod, climbed up to the seat of the Lariat and shut the door.

Brynna had turned toward the house, so as not to watch his truck disappear down Lost Lane and head back toward the airstrip, where he would fuel a plane to fly into the midst of the fire.

There was more to the man than he'd ever let her see. He was more unselfish, braver; less the thoughtless, carefree, good-time Charlie that she'd believed. He played the part perfectly, though, perhaps as a result of having to define himself in his own family.

There was more to him than met the eye— even though what met the eye was pretty great.

Brynna rolled over in the bed and stared at the dark ceiling. There had to be more to their relationship, too, more than just sex. More than even mind-blowing, every-nerve-ending-aflame sex. There had to be trust, respect. There had to be love.

The following morning as Brynna grabbed a bagel and a glass of juice between rounds, her pager went off. She checked the gadget to find Melanie's number and used the phone at the nurses' desk to call her sister. "What's up, Mel?"

"I'm strapped for a sitter tonight," her sis-

ter said breathlessly. "Frank has to work, and I'm supposed to be starting my first real estate class."

"Real estate? When did you decide to do that?"

"I'd been thinking about it, and Frank finally agreed we could make it work. But he claims I have to manage to find proper care for the boys, even though he's the one who messed up the schedule by having to work."

"Well, good for you, Mel," Brynna told her. It sounded to Brynna as though Frank still needed to adjust his thinking, but she didn't remark on it.

Instead, she thought about the conversation she'd had with Dev the morning before, how he'd pointed out her tendency to allow Melanie and Tuck to rely on her, even at the expense of her own needs. There was no reason why Melanie couldn't find someone trustworthy to watch the boys when needed.

"I'm sorry, but I have other plans," she told her sister for the first time ever. Not because she didn't want to keep the boys, but because their care was something for which Melanie needed to take responsibility. "Why don't you

call Susannah at Rugrats? I believe they take drop-ins."

"Oh," Melanie said, obviously surprised. "Oh, well...okay."

Brynna waited nervously for her sister's reaction, holding herself back from justifying her decision with an explanation.

Chapter Twenty-Two

"I guess I could try there," Melanie said at last, having had a minute to think over the situation.

Brynna breathed a sigh of relief and felt tension she hadn't noticed was there leave her shoulders.

"Susannah might have some evening time available," Mel continued, "or at the least, she'd probably know someone she can recommend."

"I'm sure she can," Brynna told her, biting her tongue to keep from adding that Mel could call her if she didn't find someone.

"Okay, then, have a good evening." Melanie wished her goodbye and hung up.

Brynna stared at the phone after placing the receiver in the cradle. An odd sense of freedom washed over her, a feeling she hadn't expected, because she hadn't known she was feeling imprisoned to start with. Standing there thinking, she realized she had taken responsibility for her siblings ever since she was old enough to recognize that their parents weren't doing a good job. She'd been about eleven at the time.

For the most part, she'd behaved like an enabling mother, allowing Mel and Tuck to take advantage of her, though she didn't think they'd grasped the fact any more than she had. Kurt had always been his own person, not as needy or as dependent.

"Everything okay?" Rae Ann asked from where she stood, making notes on a chart.

Brynna looked over at the young woman. Everything was better than it had been for quite a while. And she had Dev to thank. "Yes." If only things between the two of them could be solved that easily. "Almost everything," she added.

Rae Ann answered the phone. "Just a moment, she's right here." She put the caller on

hold and gestured to Brynna. "It's for you. Line seven."

"Thanks." Brynna answered the call. "Dr. Holmes."

"Got a minute?" Kurt asked.

"Sure. What's up?"

"I was wondering if you had time to meet me for lunch today."

"I can work that out. What time?"

"Eleven-thirty?"

"That works. Where?"

"Well, the Calico Diner has the best food."

"See you there," she said.

She hung up, looking forward to seeing her brother, while at the same time, wondering why he'd wanted to meet her. Whenever one of them called to plan a lunch, there was usually something to discuss. She guessed she'd know when the time came.

Dev accepted the check and signed papers that would turn ownership of *Sky Spirit* over to the man who stood beside him. He tucked the check into an envelope and placed it in the flight bag which held the personal items he'd taken from the ultralight.

"I know you'll enjoy her," he told Craig

Hanson, the dark-haired fellow from Helena who'd immediately arranged to meet Dev at the airstrip after Dev had called him the night before.

"I know I will, too," Craig replied with a smile. "I'm glad you kept my number and called me when you were ready to sell."

"I'd had a couple of offers, and yours was the best."

"You're not giving up flying?"

"No. I'm just removing a point of contention from my life."

"Don't tell me. The little woman's jealous," Craig said. "I've been divorced for two years now, so that won't be a problem for me. My wife thought I never paid enough attention to her, too. Women," he said with a shake of his head.

It wasn't like that at all, but Dev wasn't going to discuss his decisions and his relationship with a stranger. The plane hadn't come between them, but his behavior had. He'd let *Sky Spirit* be a symbol of freedom, which he didn't really feel the need for anymore. Selling it was a gesture of commitment to the woman he loved.

The friend who had flown Craig to Rumor, and who had been waiting until the sale was

agreed upon, now taxied his plane down the runway and took off.

Dev and Craig spent a few minutes discussing the differences in flying an ultralight, and Dev pointed out some modifications he'd made to the instrument panel. Within minutes *Sky Spirit* was airborne and a dot on the horizon.

Without a backward glance, Dev strode to his Cessna and tossed his bag in. Selling the aircraft, seeing it go, was not as difficult as he'd once thought it would be. And the check would allow construction on the log home he'd been thinking about.

He'd had his eye on a place between Rumor and the Holmes ranch that would be a perfect spot. Plenty of land to have horses. A good location to raise a family.

All he needed was a wife. His wife. Brynna, the woman he loved. It had become clear to him that she wasn't over him either, and he didn't think she wanted to be.

He simply had to figure out a way to ask her to start over. And pray she was willing. He did a preflight check, fueled and took off as planned, wanting to help with the fire and rescue effort. He would have time in the air to think.

* * *

Brynna found a parking place on Kingsley Avenue and made her way to the front of the Calico Diner, a long, transformed mobile home. The nostalgic interior was straight out of the fifties with framed pictures of Elvis, Marilyn Monroe and other stars.

The waitresses called a hello and a few customers, including Dev's aunt, Louise Holmes, who was seated with friends, greeted her by name. Brynna greeted them, found her brother at a booth, and sat across from him.

A waitress took their orders immediately. Kurt ordered the works: burger, fries and a shake, but Brynna asked for a salad and a glass of milk.

"I'm saving myself for pie and coffee," she said with a grin.

"Thanks for making the drive to Rumor to meet me," Kurt said. He wore a blue shirt and a patterned tie and looked every bit the handsome professional.

"No problem," she said. "I feel like I've been out of it lately, where you and Tuck are concerned. Dev told me Tuck is all set up in California. Job and everything. I didn't realize Dev had handled all that so quickly."

"Tuck likes the place," Kurt replied. "How about you, Brynn? Are you doing okay? Are you handling what happened? The miscarriage, I mean."

Brynna laced her fingers and looked into Kurt's concerned eyes. "It still hurts," she admitted. "I don't know what I'm supposed to feel. But I don't think about it all the time. I'm not depressed. But a lot of other stuff has happened, too."

"Like what?"

Brynna couldn't form words.

"Is it you and Dev? I know he's not living at the house."

Sure, he'd heard. And that was probably why he'd wanted to talk to her. "I'm sure everyone knows by now."

"What happened?"

"It's complicated," she said evasively.

"I can't imagine what either one of you could do to get to the point of breaking up," he said.

"I can't really imagine it either."

"I haven't called until now, because I didn't want to pry into your business."

"It's not prying," she assured Kurt. "I know you care."

"Sure I care. What's going through your head?" he asked.

She didn't really know what she wanted to say to her brother, but she felt a pressing need to talk to him. "A lot. I've been doing a lot of thinking. Having some revelations about my life."

"Sounds painful."

"It is.

"I've even been thinking about how we grew up, and about how things were at home, with Mom and Dad. Or rather *without* Mom and Dad." She took his hand on top of the table. "I'm proud of you—how you turned out."

"I'm proud of you, too, sis," he said, his voice thick. Her words embarrassed him.

"You were more self-sufficient than Mel or Tuck," she said. "Or was it just that they were more demanding, so you did more for yourself because you had to?"

"That's deep, Brynn. I don't know."

"I don't know either."

He glanced out the window, as if in thought, then back at her. "Mel's a girl, she needed you. And Tuck was the baby. He needed all of us."

The waitress brought their drinks and left. Kurt tasted his shake and said, "Sometimes I

think you never had anybody to take care of *you*. You were the mother, the one in charge. But you didn't get much help."

"Yeah, well, I've decided to start taking care of me," she answered.

"Good. You've done enough sacrificing."

"It wasn't all a sacrifice."

"Yes, it was. Don't minimize it."

She shrugged, but smiled. "Okay."

"And Dev," her brother added. "He can take care of you if you let him."

But she hadn't. She'd never let anyone take care of her. Back to that matter of pride. She was the strong one, the one who took care of others.

"Whatever it is that you're not saying," he went on, "I know it can be fixed. You and Dev are good for each other."

"I don't know about that."

"How can you not? I never saw you laugh so much until you were with him. He brings out something in you that makes you not so serious all the time."

He was exactly right. She'd never had much fun before Dev. By example, he'd shown her how to interact with her family, not just take care of them.

"You're wise for someone so young," she told her brother.

"Yeah, well I had a good example," he replied.

Brynna's throat closed with emotion and love. "Thank you, Kurt."

"Thank *you*, Brynn."

Their food arrived and they ate, the subject turning to other things. After Brynna had enjoyed dessert, he walked her to her car, and they said their goodbyes.

Driving back to Whitehorn, Brynna had time to think over the day, what had happened with Melanie, and her talk with Kurt.

They were all a product of their past: their childhoods, their parents, their past relationships, their experiences. Everyone made choices based on previous programming—or because of their history, good or bad. Just look at the first night she'd impulsively slept with Dev. It was completely uncharacteristic of her, and she'd questioned her choice ever since it had happened.

Maybe all this other bad stuff had happened because of that one bad choice.

But thinking back, she remembered the way she'd been drawn to Dev—the physical attrac-

tion played a big part, sure, but there was more to it. The way he made her feel: safe, loved, cared for, *special*.

Tears came to her eyes. She'd sacrificed youth and relationships and time to make her siblings feel important. Everyone needed to feel valuable, and their parents had not fulfilled that basic need. Mel and Kurt and Tuck needing her had made her feel important. She was their rock, their anchor. But there had never been anyone who valued her as a person just for herself, instead of as a caregiver.

Not until Dev.

As the realization swept over her, she pulled over to the side of the highway and cried. Maybe that's why she'd been so desperate for a career as a doctor, so determined to give birth to children of her own—so that she could feel significant to all those people, because she'd never been made to feel of value.

Dev had loved her for herself. He had wanted to give to her, pay for things, but her pride hadn't allowed that because she was afraid. Afraid of him not needing her the way she needed him.

No. *Get honest, Brynna. Hiding the truth from yourself will only bury this problem deeper.*

She'd been afraid of needing him. Period. There.

An enormous weight lifted from her soul. She was a person of value. Even if she hadn't become a doctor. Even if she never had a child of her own. Even if she and Dev couldn't work out their problems. And it was okay to need help once in a while. And it was okay to need Dev.

On top of that realization came the next thought. Dev had never been shown love or appreciation by his parents either. Was that why he'd spent his life proving himself at one profession and then another? So that he could validate himself? Show his parents he had worth?

Maybe they'd both been seeking the same thing, but had gone about it in completely opposite ways.

That first night with Dev had been her reaction to years of questioning her worth. A desperate attempt to grab something she wanted for herself. Perhaps their relationship had been hasty, but if it had led to love, so what?

Brynna wiped her tears, blew her nose and drove to the hospital with a renewed sense of hope—and a new regret shoving its way to the forefront of her thoughts. She had held what

she perceived as Dev's lack of commitment against him. Even when he'd shared his feelings and apologized for his initial reactions to her pregnancy, she'd been too proud and too hurt to do what he'd done immediately.

She had not forgiven him.

Her pager beeped on her waistband, and she looked at it to see the hospital emergency number. Picking up her pace, she hurried toward the ambulance bay.

Chapter Twenty-Three

The chief of staff was waiting for Brynna in admitting when she arrived.

"An emergency?" she asked, glancing down the deserted hallway.

"Not here," he replied. "At the camp. The fire has taken a turn for the worse and they're short of medical help. I promised them a triage team for the rest of the week. I need you to take charge. We'll cover your rounds here."

Brynna felt woefully inept at triage, having had only one emergency rotation, but she put in her hours here when needed, and she would do her best. The chief of staff was ei-

ther desperate or he trusted her more than she trusted herself.

"Who's on the team?"

"Emma," he said, and Brynna sighed a breath of relief that the veteran nurse would be with her. He listed the rest of the nurses, including Rae Ann, and she nodded her compliance.

"Pack a few things and plan to stay there," he told her, "rather than try to drive back, otherwise you'll never get any sleep. The camp facilities are primitive, but there are plenty of supplies and medicines."

Brynna called each of the team members and arranged a time and meeting place for departure, then drove home to get her things. Taking a van belonging to Judy, one of the nurses, they headed for the fire on schedule.

Once again, Brynna was astounded at the damage that had been done to acres of timberland. Eerie plumes of black smoke rose from farther up the mountainside where the fire had spread. Following the directions they'd been given, Judy drove them to where the temporary camp had recently moved. The van pulled to a stop and Brynna and her team got out.

The camp was organized with smaller sleep-

ing tents on one end, supply tents in the center, and the larger tents, used for treating patients and serving food and water, on the other side.

A dozen weary firefighters were sharing a meal at tables placed out in the open, and a volunteer moved among them pouring coffee. One of the men waved to Brynna.

She recognized Ash McDonough, set her bags aside, and walked toward the tables.

"Hi, Brynna," he said.

"Ash."

"This is Dr. Holmes," he said to the others.

Several of the men, fatigue etched on their dirt-smeared faces, welcomed her.

"My unit is moving farther up the ridge today," he told her.

"Have you seen Dev?" she asked.

He shook his head. "I heard he's flying out of another command post. One specifically for air rescue and spraying."

A plane flew over just then, and they both glanced upward for a moment.

"Well, take care of yourself," Ash said to her.

"You, too."

The men finished their meal and threw away their disposable plates and cutlery, grabbed

bottles of water from a pallet of cases nearby and walked toward their vehicles.

Behind her somewhere, a male voice called out a request for bandages. A man came out of the nearby tent with a bucket and rag and wiped the tables.

The bustle of activity instilled a sense of urgency and purpose, and Brynna turned back to find her team. They were stowing their gear, and she dropped her flight bag on the pile. Finding her other bag, she ignored prescription pads and her phone to pull out her stethoscope and drape it around her neck.

She was as ready as she'd ever be.

"Go rest," Emma told Brynna with a stern look and a push toward the sleeping tents. "It's one in the morning, and the rest of us have had a nap. I'll handle this turkey."

She referred to a firefighter who had been treated and was currently arguing with Rae Ann because he didn't want to use the oxygen mask a minute longer.

Trusting the nurse to intimidate the fireman into staying put another fifteen minutes, Brynna thanked her team. "You're doing a

great job. I'm going to try to sleep for an hour or so. If you need me, come get me."

Brynna stumbled into the tent where she and the nurses had stowed their belongings that afternoon. It seemed like days had passed. She was sweaty and grimy and could taste smoke with every breath. She switched on a solitary bulb hung from the canvas ceiling. The camp operated on generators, thank goodness, but their assigned accommodations afforded little more than cots and a light.

Brynna poured water from a plastic jug into a basin. She washed her face, used disinfectant on her hands, and rinsed. After unpacking her hairbrush, she let down her hair and ran the bristles through. Her entire body was weary, and this was only the first day. The tension increased the fatigue. She couldn't imagine what the firefighters must feel like.

She'd spent the entire evening treating smoke inhalation and first-degree burns. Her admiration for those men had grown in leaps and bounds. Even exhausted and wounded, they resisted prolonged treatment in their hurry to get back to their positions.

Every time she heard a plane in the distance, she thought of Dev, and wondered if he was

nearby. Exhausted, she lay down and immediately fell asleep.

At five she was up for the day, dressed and in front of the triage tent. Emma brought her coffee in a foam cup. "Rested?"

Brynna nodded.

"I've never seen anything like this, have you?" Rae Ann asked, coming to stand with them in front of the tent.

The entire area was crawling with firefighters, teams of medical professionals and even members of the press.

"Only on television," Brynna replied.

"I helped with a fire once before," Emma told them.

"I can't believe the stupidity of that couple," Rae Ann said, scorn in her tone. "All this, all these people hurt and the forest burned because that Cantrell woman and her lover had a campfire they weren't supposed to have. Why the heck did they need a campfire in broad daylight, during a drought no less, if they weren't cooking?" She cocked her head and added, "And they obviously weren't cooking."

"Remember that fire in Colorado that was started by a female forest ranger burning old love letters?" Brynna mentioned.

"Seems I remember she just made that up," Emma replied.

Brynna sipped her strong hot coffee. "Well, nothing logical about that incident either. Pure carelessness on both counts."

A helicopter's loud rotor drowned out Emma's next remark, and the three of them ran toward the landing area.

Brynna closed her eyes against the swirling dust, blinked and made out the chopper as it landed. The door slid open. Brynna recognized a paramedic who worked in Whitehorn. "Dr. Holmes!" he called, seeing her.

Brynna ran forward, ducking under the blades.

"Twenty-eight-year-old male with a possible pelvic fracture," he yelled over the noise. "I think he might be bleeding internally."

Emma was right behind with Brynna's bag. Brynna checked the patient's vitals. "I think you're right on both counts. Let's get him to Whitehorn. I'll come with you to keep him stabilized."

Turning back to Emma, she said, "Any cases that need a doctor, turn over to one of the other teams until I get back."

Emma nodded her understanding and backed away.

Brynna climbed aboard the helicopter and nearly fell on top of the patient as the pilot immediately put the craft in the air.

"This isn't looking good," the pilot called back.

She saw what he was talking about. Flames were licking the edge of the ridge, just a little over a mile from their camp, and he had to fly a wide circle around the heat and smoke.

She'd barely returned from that flight when a volunteer with a broken leg was brought into camp in the back of a pickup. She was administering a sedative, when shouts came from outside the tent.

"We have to get out of here!" Emma said, her face flushed, her white jacket streaked with dirt. "The wind has changed, turning the fire back, and our camp is right in its path. They're evacuating us."

"Get this man on a chopper," Brynna said, calling instructions to the other nurses. "Pack everything you can in the van and we're out of here. Bring me ice."

"They can't get a helicopter back in," Emma said, after using a phone.

"Then we'll have to take him with us. Help me get his leg stable."

The man, tall and probably in his thirties, grimaced, showing white teeth against his darkened face.

"What's your name?" Brynna asked him.

"Don Hinkle."

"Well, Don, you're about to get the ride of your life. I've given you something for the pain. It'll kick in in a minute here. I don't want to risk setting that leg without X rays, so we'll pack it in ice until we get you to the hospital."

The camp was a mass of confusion and panic, with medical personnel packing supplies and running and calling out to one another.

Brynna helped lay down all the rear seats in Judy's van. Judy started the engine as four of them lifted the stretcher bearing the wounded Don into the back and packed bags of ice around his leg. The team squeezed in around him.

The man's dirty face was streaked with sweat, and he held back exclamations of pain.

"It's okay, Don," Brynna assured him. "We're out of here, and you'll be at the hospital soon."

With everyone in and the doors closed, the

driver headed away from the fire. Other volunteers, also fleeing the camp, moved out of their way.

As they bounced along the dirt road they'd traveled to get there, the sky grew darker than ever. A squat man in a coat and fire helmet flagged them down at a turn in the road.

Judy rolled down her window.

"Can't get through here!" he said to her and peered at the passengers. "We've got a firestorm raging ahead."

Brynna's chest contracted with fear. This had been the only way in to the camp when they'd arrived, and the fire was behind them as well. They were trapped.

Dev had been flying one of the planes, specially equipped to spray chemicals, when he got the message via his radio that medical workers were trapped in the fire. He froze for a full minute, then assured himself that Brynna was safe at the hospital. "Come back for refueling and new tanks," the coordinator said. "We need as many sprayers over the access road as possible."

"Affirmative." To reassure himself, he grabbed his phone and dialed her number.

There was no answer, but she always shut it off when she was on duty and took only pages. No cell phones were allowed in the hospital.

He called the hospital and asked for her.

"Dr. Holmes has been at the encampment since yesterday," the woman who answered told him, the unmistakable edge of fear in her voice. "We just got news that the medical teams are trapped."

Dev approached the temporary landing strip where one plane was already heading back out.

"Who is trapped?" he asked the flight coordinator over the headset. "Do you have names?"

"Don't know. There are four vehicles trapped on the road. Reports say they belong to the medical volunteers who were doing triage."

For a moment, he couldn't breathe. Life didn't matter in the least if anything happened to Brynna. Terror twisted his heart and made his ears pound with the rush of adrenaline. She was trapped on that road, directly in the path of the fire.

Chapter Twenty-Four

Dev checked his coordinates and made his second sweep over the area where the access road was supposed to be. He knew it was down there, but he was flying blind through the smoke. The team effort had to be well linked or a midair catastrophe could occur.

For those few seconds that he could see nothing but dense gray smoke, it felt as though he was the only person on earth. He had to overcome the gnawing uncertainty of what was ahead, swallow the panic and trust his gut instinct and the instruments. "This is just like flying through fog," he told himself aloud.

As the chemicals doused the fire, more smoke curled behind him, and he broke out of the blind area. He had enough in the tanks for one more pass, so he checked with the co-ordinator before taking another sweep.

This time, the billowing clouds of gray had dispersed on the wind enough to allow him a clear view of a stretch of curving road, the foliage on both sides blackened.

Through the break in the dense cover, he spotted several vehicles; one, a van, had a tree lying across the hood and windshield. Ahead of it were rescue vehicles, red lights flashing. A bleak scene.

All that mattered was getting the road open so those people had a route of escape, and he focused on that purpose, not allowing himself to wonder if Brynna was down there—if she'd been a passenger in that van. If she was, he could best help her by continuing this task.

"I see the vehicles," he told the coordinator. "There's a tree on a van."

"We're in contact with the rescue team on that road," the voice replied. "They were transporting one injured passenger, and two more were injured when the tree hit them."

"I'm coming back for tanks," Dev reported. "Keep me posted."

"Ten four."

It was another hour before the road cleared and Dev reported that the vehicles had a window of opportunity to pass through.

"What's happening?" he asked the coordinator.

"They had to leave the van and managed to get all the passengers into other cars and trucks and they're headed for Whitehorn."

"How many more passes, do you think, until we have that stretch under control?"

"Right now, you can see that better than I. I'll ride along on your next flight to assess."

"I think my wife was with that crew."

"It's your call," the disembodied voice told him.

"I'll keep at it until you think the danger is past."

Grabbing his phone, he punched in the number for the hospital.

"Sorry, if you've heard that our team is out of the danger, you've heard more than we have," the person who answered the phone said. "They haven't arrived here yet."

"They'll be coming, and my understanding is they have three injured," he replied.

"We're ready."

Dev grabbed a paper towel and wiped sweat from his face, barely noting the grime he wiped away with it. Why had he waited? He'd had her in his arms just days ago. Had danced with her, made love to her, slept with her wrapped against him.

At any moment, he could have said "I love you. Please, let's try again." He could have told her he couldn't live without her, could have proposed.

Emotion made his throat tighten.

It wasn't too late. It couldn't be.

It was another hour before he got the all clear. The trucks and medical personnel were safely out of the area, and the rest of the camp had been evacuated. Dev landed the plane and ran for his Cessna, doing a cursory preflight before heading for Whitehorn.

It had never taken so long to fly such a short distance. After he landed, he had to borrow a car, because he'd departed from Rumor and that's where his truck was still parked.

Another pilot took pity on him and loaned

him a car, and Dev forced himself to drive the borrowed vehicle safely.

There was no doubt in his mind. He couldn't live without Brynna. If anything happened to her, he'd always regret the time he'd wasted and the words he'd left unsaid. By the time he reached the hospital, found a place in the mass of confusion in the parking lot and ran inside, his heart was in his throat.

Television cameras and reporters clogged the entrance, and a harried security officer tried to stop Dev from entering.

"I'm Dr. Holmes's husband, and you'll let me in or I'll toss you out there to those reporters."

"Sorry, Mr. Holmes. It's been crazy. Go on in."

Dev ran past him, hurrying down the corridor. Patients lay on gurneys on both sides, and Dev glanced at each one he passed. He recognized a volunteer fireman.

Two nurses were at the desk, one dressed in scrubs with her hair wet. She had a red scratch on her cheek.

"Where's Dr. Holmes?"

"She's in one of the curtains back there," the young woman told him and pointed.

This moment felt worse than the day he'd come running to the hospital after he'd received the call about the baby and found her lying on a bed. What had happened?

Checking behind each curtain and not seeing her, he fought panic for the second time that day.

At last he heard her voice.

"Brynn!" Dev thrust back the last drape.

She stood beside a bed, a chart in her hand, looking down at a man with a cast on his leg. She looked up. "Dev!"

"Oh, God, Brynn, I thought you were hurt!"

She met him at the foot of the bed and they embraced.

"I'm okay," she said, her voice shaky.

He kissed her beautiful face a dozen times, then her lips. "I was so scared. Brynn, I have been so stupid."

"Me, too."

"No, it's been my fault. And I was too proud to say so."

"No, you weren't, you said you were sorry, but I didn't forgive you. Not really. You forgave me, I'm the one at fault."

"No," he argued, kissing her again.

"Oh, for crying out loud, just agree that you were both a couple of idiots and get to the good part."

Brynna came out of her emotional daze long enough to glance at the speaker. Emma had pulled back the curtain, and half a dozen members of the medical staff as well as the patients in the other beds were watching them.

The man with the cast on his leg grinned. "Kiss the doc again."

Brynna looked up at Dev. He was almost as dirty as everyone else she'd seen that day, his face streaked with soot and sweat. But she didn't care. She'd had a close call that day, and she'd had her own sudden insight into how foolish she'd been. She didn't intend to waste any more time.

She looked up at him, and hoped the love she held for him shone from her eyes. "You heard the man. Kiss the doc."

Dev hauled her to him in a crushing embrace, kissing her thoroughly. She blocked out the cat calls and the cheers and returned the kiss, hoping to show him he meant everything to her.

Dev broke the kiss and held her away. "We need to talk."

She nodded.

The onlookers broke up and went their separate ways, smiling.

"Dev, this is Don Hinkle. He was injured today. We shared an exciting ride back to Whitehorn."

"Did we ever," Don said with a rueful grin.

Dev shook hands with the volunteer.

"You're in good hands here," Brynna assured her patient.

"Looks like you are, too," he replied with a grin.

She smiled, but went on. "The staff will take good care of you tonight. We'll see about releasing you tomorrow."

She took Mr. Hinkle's chart to the desk and told the nurse there that she was leaving.

After making a couple of phone calls and arranging to have the borrowed car returned, Dev took her hand and led her through the throng of media at the doors, wrapping his arm around her and sheltering her from their questions and their cameras.

She pointed out her car in the staff parking lot, and he took her keys, settled her inside and got in to drive.

He wanted to talk to her right then and there, but reporters had followed them and were peering in the windows. He started the car, then backed it out and away from the hospital.

They didn't speak much on the drive to Rumor, just held hands as though they couldn't bear not to touch. Once at the house, Dev unlocked the door and ushered her in.

"You need a shower," she told him.

He swiped at her cheek. "So do you."

"Let's take one, then."

She preceded him up the stairs and into the bathroom. While Dev adjusted the water, she peeled off her clothing. He did the same, and, leaving the filthy clothes on the tile floor, he joined her under the spray of water.

"Oh, this feels so-o-o good," she said with a groan, tipping her head back and wetting her hair.

Dev found shampoo and lathered her hair, taking time to leisurely massage her scalp. The almond fragrance surrounded them, filling his senses with scenes of remembered pleasure. She closed her eyes and enjoyed, but then opened them to return the favor and wash his hair.

She chuckled and he opened his eyes. "You have black streaks running down your face," she said.

She took a washcloth, lathered it and had him scrub his face. She took it away from him then and washed his body. Dev gave her an adoring smile the entire time. He stuck his head under the spray and rinsed.

Having him here, experiencing the closeness and knowing how much he loved her brought a rush of regret and sorrow. Brynna let out a little sob.

Dev moved his face from the water to look at her in surprise. He placed his hand in the middle of her back and drew her close. "What is it?"

"I'm so sorry, Dev. I'm so sorry I couldn't just let go and forgive you like you forgave me."

Dev wrapped her in his arms, slick skin against slick skin and held her close. "Don't cry, sweet thing. We're not going to blame anyone or figure out whose fault it was. We're going to put it behind us and start over. Okay?"

She nodded her head against his shoulder. "But we have to talk about it."

He found her bath sponge, squeezed gel onto it and soaped her body. "Okay. We'll talk about it." He rubbed the sponge in circles over her breasts and belly, following the path with his hands. "Go ahead."

"I was just plain afraid," she told him. "I blew your remarks out of proportion and used them as an excuse."

"Afraid of what?"

"I was afraid of needing you. Really needing you. You were the only person who ever loved me just for me—without wanting anything or needing me."

"I need you."

"No. When we met, you didn't need help or money or medical treatment. Up until then, that was all I knew. No one had ever seen me as important just because I was Brynna Shaw. Until you. And that made me vulnerable."

"I'm glad something made you vulnerable, otherwise I might never have stood a chance with you." He moved her so the fall of water rinsed the lather from her body, then bent to kiss her neck and shoulders.

She wrapped her arms around his shoulders. "When I started to need you I got scared. I had

always been the one to care for others. Is this making sense to you?"

"Mmm-hmm," he said against her collarbone.

"And you wanted to take care of me."

He stopped the nibbles to look at her. "I still do."

"But now I'm not afraid to let you."

"Really?"

"Really."

"I can pay for things?"

"I think so."

He grinned and hugged her.

Brynna turned and shut off the water. They dried each other off, taking time for kisses and caresses. Brynna dried her hair quickly, with Dev leaning against the counter watching, a smile on his face, the towel around his hips. She knew how he felt—she didn't want to take her eyes off him or be separated for a moment, either.

Dev took her hand and led her into the bedroom. He couldn't get close enough and held her tightly to him. She pulled her towel away and then his and raised her face for a kiss.

He was happy to oblige her, tasting her sweet lips, inhaling the scent of her hair that

surrounded them, feeling the brush of her moist skin against his from breast to hip.

He wasn't going to waste another minute. "Brynna, will you marry me?"

Chapter Twenty-Five

"For real this time. Forever," he said emphatically.

Love and relief and joy rose up in Brynna—so much emotion, she couldn't contain the feelings. She burst into tears and sobbed against his neck.

"Brynn, Brynn, what is it? What did I say? Don't you want to marry me?"

She nodded, and he forced her head back to look into her eyes. "Yes," she said. "I'll marry you."

"Don't scare me like that," he said, then crushed her to him in a tight embrace.

He kissed her and she returned the kiss with all the passion she'd been holding back, all the love she knew how to express, with all the feelings of admiration and appreciation she had for this man brimming over.

They landed on the bed in a tangle of arms and legs and didn't take time for a gradual lead-in to the comfort and assurance they both sought. Dev pressed into her and she took him with a primal urgency, their lovemaking as incredible as always, but impatient, demanding.

Afterward, when she lay in his arms exhausted and content, Brynna stroked Dev's chest and pressed kisses against his shoulder.

"Have I ever told you that you're the man of nurse dreams?"

"Don't you mean doctor dreams?"

"That, too."

"No, you haven't."

She told him how the nurses had all been talking about him that first night at Joe's Bar. "And I was the lucky one you singled out," she said.

"There was something about you the first time I saw you," he said. "I just knew I wanted you."

"I thought you were nuts, asking me to marry you the first night we met."

He stroked her arm. "I knew I'd found a good thing with you."

She leaned up, her chin on her wrist, to look at him. "You've taught me so much, Dev," she said.

"I've taught you? That's unlikely."

"Not at all. You showed me how to have fun. How to enjoy my family and not just take care of them. I used to feel like I was the only person being responsible and everyone else was just goofing off."

"You let everyone else goof off," he said, "by doing everything for them."

"I see that now, but I didn't back then. I never let loose and had fun until you showed me it was okay."

"That's me—Mr. Fun Guy," he said drily.

"No." She touched her finger to his chin. "I was wrong about you not being responsible. You've taken care of things I wasn't even aware of at the time. You took care of Tuck's college expenses and living arrangements. You tried to take care of me. You're kind and you're hardworking, and I was wrong about your flying. It was silly to feel jealous."

"No, you weren't. It was an escape for me, a freedom I was holding on to."

"Maybe it's a freedom you need and deserve. It's not freedom from *me* you seek up there, Dev, not freedom from responsibility. I see that now. Flying is important to you. It rounds you out."

"There is one less plane I'll be flying from now on," he said.

"What do you mean?"

"I sold *Sky Spirit*."

She sat up on her knees and stared at him. "You what?"

"I had several offers, you knew that."

"But you scoffed at them."

"I sold it to prove something. Maybe not just to you, but to myself, as well."

"To prove what? You don't have to prove anything to me."

"That I didn't need that escape. That I was happy here. That there are plenty of other things that matter more."

"I already knew that," she said. "I'm sorry you felt like you had to do that."

"I didn't feel like I had to do it. I wanted to." He twisted to prop the pillows behind his shoulders and leaned against them. "I used

the money to buy land and contract for a log home."

Brynna stared at him in surprise. Had he planned to build a place for himself? "Land where?"

"Between here and the Holmes ranch. Still an easy drive for you to make to the hospital."

He'd selected the site thinking of her drive to work, thinking of them as a couple. The gesture warmed her all the way through. He was a man full of surprises. "When did you do all this?"

"As soon as we came back from Seattle."

"In two days?"

"Yep."

"You were planning the house for us? Together?"

"Of course. I was trying to figure out how to ask you to start over."

"Just asking might have worked."

"I didn't know if you were ready."

She had to agree that he might have been right to wonder. "I don't know if I was ready either. I wanted to fix things between us. But I still didn't have everything sorted out. I've realized a lot about myself in the last few days."

He caressed a lock of her hair. "All I care about is that you realized you wanted me."

"I do."

"Say that again?"

"I do?"

"No, with more certainty."

She smiled. "I do."

Dev framed her face with his hands. "Get those words just right, because you're going to be saying them real soon."

"How soon?"

"As soon as we can arrange a wedding."

"What will we tell people?"

He ran his thumb over her cheek in a gentle caress. "What do you want to tell them?"

Brynna thought that over and realized something she hadn't imagined she'd feel. "I want to tell them the truth. We were married illegally, but we're going to marry again because we want our marriage to be legal…and forever." She grasped his wrist. "Is that okay?"

"That's more than okay. I think that's the best thing we could do. No secrets." He kissed her lips tenderly. "What about the lawsuit? Do you want to be involved?"

She'd thought it over and had never been

comfortable with the idea. "Do we need the money?"

He grinned. "No."

"Do we want reimbursement for pain and suffering?"

He shook his head. "I don't."

"Neither do I. We'll let them take action without us then, okay?"

"Okay."

"But Dev?"

"Hmm?"

"I don't want you to give up something you love as much as the ultralight. And we had planned a honeymoon to Kenya, remember? What will happen with that?"

His eyes searched hers. "We don't have to make that flight, Brynn. We'll take any honeymoon trip you'd like. A cruise, maybe."

His generosity touched her. She'd made him think she'd never wanted to take that trip in the first place, and that just wasn't true. She shook her head. "I was hurt and said some cruel things." She kissed him. "I'm sorry. I did want to take that trip with you. Truly."

"You did?"

She nodded. "I still do."

"If you're sure."

"I'm positive."

"Then Kenya it is."

"Can you buy back *Sky Spirit*?"

"No, but I can build us a new one."

She smiled with unrestrained happiness. Everything was going to be all right, and they were truly going to start over fresh. She hadn't made an impulsive mistake with Dev after all. He was exactly the right mate for her. There was no longer a shred of doubt in her mind.

An hour later, they were dressed and sharing an omelet at the kitchen table.

"I've been thinking about something else," Dev told her.

"What's that?"

"I've been thinking about buying a couple more planes, functional ones."

Brynna nodded. "Okay."

"And starting my own outfitting charter. I can hire a couple of pilots and guides, and we can fly hunters and fishermen over the Rockies. Corporate types will pay big bucks for the service."

Brynna studied him with surprise. "How long have you been thinking about this?"

He shrugged. "A while."

Running his own business was a commit-

ment he was apparently ready to make. "If that's what you want to do."

"I do."

She grinned. "Now *you're* practicing."

"I promise not to miss holidays, anniversaries or birthdays, okay?"

She nodded sheepishly.

"And especially not the big events."

"What's bigger than any of those things?"

He reached across the table for her hand. "When our kids are born."

Brynna clasped his hand with a lump in her throat. Around it, she managed to say, "Dev, even if we never had another baby, it would be okay. We have each other, and I am fulfilled with our relationship and my career."

"Me, too, Brynn. But we will have a baby. And I want you to know you can count on me through all of it—not just the birth."

"I already knew I could count on you, but thanks for saying so."

They shared a smile.

"But just so you know, if you did miss that big event, you could just keep on flying, buster."

He chuckled and drew an X on his chest. "I'll be there."

* * *

The following day, Dev and Brynna told their friends and family about the situation they'd found themselves in and invited everyone to their wedding.

Before the gossip about the Holmes's illegal marriage had a chance to die down, new rumors flew and distracted the townspeople. Brynna and Dev heard from Dev's aunt Louise, who heard from Donna Mason, who owned the Getaway, who heard from Linda Fioretti, the art teacher at Rumor High School, that Linda had received a phone call from the missing suspect, Guy Cantrell.

The news was the oddest rumor ever to spread through the small Montana town: Guy Cantrell was claiming to be *invisible*.

Epilogue

Nine months later

"Eight, nine, ten," Dev said. "Okay, relax."

"You said for real this time. You said forever. You promised for better or for worse." Brynna huffed and gritted the words at her husband.

"That's right, sweet thing," Dev told her, not moving a muscle in reaction as she crushed every bone in his hand with her iron grip.

"It doesn't get any more real than this," she said.

"This is real," he agreed.

"And it doesn't get any worse," she panted.

"No, Brynn, it doesn't get any better."

"That depends on whether you're *on* this table or beside it."

"You're doing great, we're almost there."

"Do you know how many women I've said that to?" she asked. "And lied?" Brynna turned her head and found an OB nurse who was checking her pulse. "How many women have you said that to?"

"Thousands."

Dev couldn't help a chuckle.

"Okay, Brynna, take a rest between contractions," Dr. Atwood said kindly, giving her encouragement with his eyes. His blue mask obscured the rest of his features.

"Rest. Now that's a joke. There's a baby clawing its way out of me and you want me to rest."

"Maybe if you just lay there and didn't say anything for a few minutes, sort of got your second wind…" Dev, too, wore the obligatory mask, cap and gown. His green eyes glowed with love and concern.

Exhausted, Brynna stared at the ceiling. "I will never look at a patient the same way again," she said.

Dev rubbed her arm and kissed her forehead. "You're doing great."

"Okay, here comes another one," Emma said from beside her, where she watched the monitors. Brynna had requested her presence in the delivery room.

Kelly Brenner, the pediatrician, stood waiting just behind the doctor.

"We're almost there," the doctor said. "Concentrate on pushing this time."

"What do you think I've been doing?"

"Push, Brynna," Dev said. "One, two, three, four..."

Brynna pushed.

"There's his head," Emma said. "Look, Daddy."

"Five, six, seven, eight..."

"You're doing great," the nurse said from her position at Brynna's knee.

"Nine, ten. Okay, relax."

Brynna let out her pent-up breath and lay back. Dev wiped perspiration from her forehead and rubbed her arm soothingly.

"He'll be out with the next one, Brynna," Dr. Atwood assured her.

She nodded.

"In the next few minutes we'll know if it's a girl or a boy," Dev said to her. They had declined knowing the sex of their baby, want-

ing instead to be surprised. Brynna closed her eyes and waited.

Emma had her hand high on Brynna's abdomen and her eyes on the monitor. "Okay, here it comes. This is the one. Take a deep breath."

Brynna garnered her last reserve of energy, inhaled and leaned up. Dev helped support her shoulders.

"Here comes your baby," the doctor said. "Bear down."

"There's the head," Dev said.

With a final burst of energy, she pushed and felt the oddest sensation of a lifetime as her baby slipped from her body into the world.

Dr. Atwood held the infant with its feet upward and Kelly, who'd been standing to the side, moved in to suction mucus from the baby's mouth and nose.

"It's a girl," Dev said with excitement lacing his voice.

"A girl?" Brynna breathed. Emotion overcame her at the sight. She'd seen hundreds of babies born, but this one was her own.

The pediatrician had taken the baby and was wiping her clean with soft cloths. She then placed their daughter on her side on a flannel blanket on Brynna's chest and continued to

rub her skin. The tiny girl's arm flailed. "Hold your baby," she said.

Brynna tucked the little arm down and wrapped the blanket around her to keep her warm. She touched the incredibly soft skin of her little cheek and her downy shoulder. "Oh, look at her, she's just perfect."

"Yes, she is." Dev pressed a kiss to the baby's forehead.

She had fair hair, but her eyes, when she squinted them open and seemed to look right up at Brynna seemed round and dark. Her incredibly small mouth opened wide and a moment later, she emitted a cry.

Brynna couldn't help the tears that flowed. As emotional as she was, the doctor in her wouldn't be ignored. "Her skin's a little gray."

Kelly reached for the baby. "We're gonna take her and get her to pink up a little bit. She'll be back after she's weighed and warmed and given her eye drops."

Brynna watched the woman she trusted take her baby.

She turned her eyes up to Dev and he leaned down to kiss her. "You did fine."

Her chest quaked with a few last sobs, and her body had begun to feel cold and shaky.

"I complained the whole time, what do you mean?"

The nurse brought her a blanket.

"Doctors make terrible patients," Emma said, assisting Dr. Atwood as he finished up.

"But this one makes a fine mommy," Dev said.

"A girl," Brynna said in amazement. "What arc we going to name her?"

"I was thinking Estelle," he teased.

Meghan Elizabeth Holmes made her public debut at the baby shower which had been planned for after her arrival, since Mommy and Daddy didn't know her gender. The event was held at the Calico Diner, and Meghan had her first look at Elvis, when her aunt Melanie held her up to the life-size cutout and introduced her to the King.

Jilly Forsythe who owned Jilly's Lilies had provided centerpieces of baby's breath and miniature pink roses.

Colby and Tessa Holmes attended, along with Dev's aunt and uncle, Louise and Bud, as well as Sheree Henry, Russell and Susannah Kingsley and their two children. Sheree and Susannah both wanted to know when Meghan

would come to Rumor Rugrats Daycare where they worked.

Jim and Kelly Brenner, both pediatricians who worked with Brynna, were there, as well as a huge assortment of family and friends who wanted to wish the family well.

"Look at those green eyes," Jilly said. "She's going to be a stunner."

"She's my cousin," Chandler said proudly. "But she can't open all those presents, Aunt Brynn, can she? Isn't she gonna need some help?"

John scurried to his brother's side. "You wasn't supposed to ask."

"It's okay," Dev said. "She really does need help, and you two are the best choices, don't you think, Brynn?"

"Definitely."

Brynna's brothers took turns holding Meghan. "Are you really disappointed that Mom and Dad didn't come?" Kurt asked Brynna.

She hadn't expected her parents to show up. "I wish they had, but I'm not going to place unrealistic expectations on them," she replied. "Some day they'll realize what they missed with their kids and grandkids."

Kurt shrugged. "Maybe."

Just then the bell over the door rang, and all conversation drifted away as attention focused on the couple who entered the Calico Diner.

Dressed in a pink chenille designer suit and carrying a stack of elegantly wrapped packages was Estelle Holmes, followed by her husband in a dark business suit. They were so out of place in the fifties diner with the room full of casually dressed citizens of Montana that the scene was almost laughable.

But Brynna found her composure and hurried forward to greet them.

Dev was right behind her. "Mother, Father," he said. "I didn't know you were going to come."

"Brynna's sister called with an invitation, and we told her we'd be delighted," Estelle replied. "Where is the little darling?"

She moved directly toward the bundle in the pink blanket now in Emma's arms.

Brynna noted her sister's sly expression. "You sneak," she said with a grin.

Dev gave Melanie a hug. "Thanks."

"You're welcome. There's another surprise you don't know about."

"What's that?" Dev asked.

"They just bought some land from me. They're going to build a vacation house in Rumor."

Brynna and Dev shared a surprised look, then turned to discover their new daughter being made over by her grandparents. Dev wrapped his arm round Brynna, and they enjoyed the sight.

Conversation and laughter rose up around them once again, and townspeople introduced themselves to the senior Holmeses. Brynna noted the love and devotion of family and community that surrounded her and Dev and their newest addition, and her heart brimmed to overflowing.

She took Devlin's hand and felt the new wedding band she'd bought him press against her palm. Thank goodness she'd had the sense to marry Devlin Holmes...again.

* * * * *

YES! Please send me **The Montana Mavericks Collection** in Larger Print. This collection begins with 3 FREE books and 2 FREE gifts (gifts valued at approx. $20.00 retail) in the first shipment, along with the other first 4 books from the collection! If I do not cancel, I will receive 8 monthly shipments until I have the entire 51-book Montana Mavericks collection. I will receive 2 or 3 FREE books in each shipment and I will pay just $4.99 US/ $5.89 CDN for each of the other four books in each shipment, plus $2.99 for shipping and handling per shipment.*If I decide to keep the entire collection, I'll have paid for only 32 books, because 19 books are FREE! I understand that accepting the 3 free books and gifts places me under no obligation to buy anything. I can always return a shipment and cancel at any time. My free books and gifts are mine to keep no matter what I decide.

263 HCN 2404 463 HCN 2404

Name _____ (PLEASE PRINT) _____

Address _____ Apt. # _____

City _____ State/Prov. _____ Zip/Postal Code _____

Signature (if under 18, a parent or guardian must sign)

Mail to the **Reader Service:**
IN U.S.A.: P.O. Box 1867, Buffalo, NY 14240-1867
IN CANADA: P.O. Box 609, Fort Erie, Ontario L2A 5X3

REQUEST YOUR FREE BOOKS!

2 FREE NOVELS PLUS 2 FREE GIFTS!

♦HARLEQUIN®

SPECIAL EDITION

Life, Love & Family

REQUEST YOUR FREE BOOKS!
2 FREE NOVELS PLUS 2 FREE GIFTS!

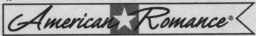

LOVE, HOME & HAPPINESS

YES! Please send me 2 FREE Harlequin® American Romance® novels and my 2 FREE gifts (gifts are worth about $10). After receiving them, if I don't wish to receive any more books, I can return the shipping statement marked "cancel." If I don't cancel, I will receive 4 brand-new novels every month and be billed just $4.74 per book in the U.S. or $5.24 per book in Canada. That's a savings of at least 14% off the cover price! It's quite a bargain! Shipping and handling is just 50¢ per book in the U.S. and 75¢ per book in Canada.* I understand that accepting the 2 free books and gifts places me under no obligation to buy anything. I can always return a shipment and cancel at any time. Even if I never buy another book, the two free books and gifts are mine to keep forever.

154/354 HDN F4YY

Name _____ (PLEASE PRINT) _____

Address _____ Apt. # _____

City _____ State/Prov. _____ Zip/Postal Code _____

Signature (if under 18, a parent or guardian must sign) _____

Mail to the **Harlequin®** Reader Service:
IN U.S.A.: P.O. Box 1867, Buffalo, NY 14240-1867
IN CANADA: P.O. Box 609, Fort Erie, Ontario L2A 5X3

Want to try two free books from another line?
Call 1-800-873-8635 or visit www.ReaderService.com.

* Terms and prices subject to change without notice. Prices do not include applicable taxes. Sales tax applicable in N.Y. Canadian residents will be charged applicable taxes. Offer not valid in Quebec. This offer is limited to one order per household. Not valid for current subscribers to Harlequin American Romance books. All orders subject to credit approval. Credit or debit balances in a customer's account(s) may be offset by any other outstanding balance owed by or to the customer. Please allow 4 to 6 weeks for delivery. Offer available while quantities last.

Your Privacy—The Harlequin® Reader Service is committed to protecting your privacy. Our Privacy Policy is available online at www.ReaderService.com or upon request from the Harlequin Reader Service.

We make a portion of our mailing list available to reputable third parties that offer products we believe may interest you. If you prefer that we not exchange your name with third parties, or if you wish to clarify or modify your communication preferences, please visit us at www.ReaderService.com/consumerschoice or write to us at Harlequin Reader Service Preference Service, P.O. Box 9062, Buffalo, NY 14269. Include your complete name and address.

HARDIR13R

READERSERVICE.COM

Manage your account online!

- Review your order history
- Manage your payments
- Update your address

> *We've designed the*
> *Reader Service website*
> *just for you.*

Enjoy all the features!

- Discover new series available to you, and read excerpts from any series.
- Respond to mailings and special monthly offers.
- Connect with favorite authors at the blog.
- Browse the Bonus Bucks catalog and online-only exculsives.
- Share your feedback.

Visit us at:
ReaderService.com